CO-ILLUSION

CO-ILLUSION

DISPATCHES FROM THE END OF COMMUNICATION

David Levi Strauss

with photographs by
Susan Meiselas and Peter van Agtmael

THE MIT PRESS
CAMBRIDGE, MASSACHUSETTS
LONDON, ENGLAND

This book was set in PF DIN Pro by The MIT Press. Printed and bound in the United States of America.

Library of Congress Cataloging-in-Publication Data

Names: Strauss, David Levi, author. | Meiselas, Susan, photographer (expression) | Van Agtmael, Peter, photographer (expression)
Title: Co-illusion : dispatches from the end of communication / David Levi Strauss.
Description: Cambridge, MA : The MIT Press, [2019] | Includes index.
Identifiers: LCCN 2019018576 | ISBN 9780262043540 (hardcover : alk. paper)
Subjects: LCSH: Communication in politics--United States--History--21st century. | Rhetoric--Political aspects--United States--History--21st century. | United States--Politics and government--2017-
Classification: LCC JA85.2.U6 S77 2019 | DDC 320.97301/4--dc23
LC record available at https://lccn.loc.gov/2019018576

10 9 8 7 6 5 4 3 2 1

Just remember,
what you're seeing
and what you're reading
is not what's happening.

Donald Trump, speaking to the national convention
of the Veterans of Foreign Wars (VFW) in Kansas City,
Missouri, on July 24, 2018

It's always hard to beat the enemy
when you can't see it.

Donald Trump, speaking to the Army's 10th Mountain
Division at Fort Drum, New York, on August 13, 2018

CONTENTS

PART II
THE NEW IMAGE

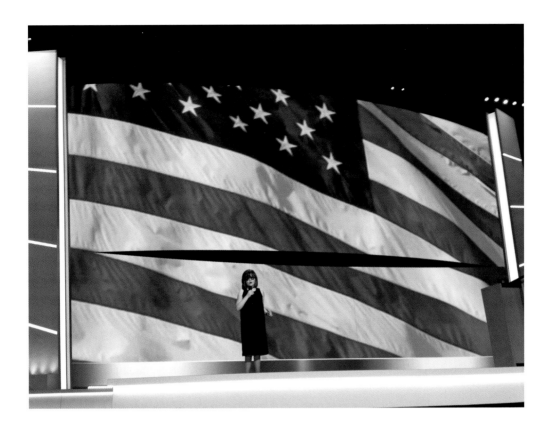

— Blind singer Marlana VanHoose from
Kentucky singing the National Anthem
at the Republican National Convention
in Cleveland, Ohio. July 18, 2016.
Photo by David Levi Strauss.

PREFACE

COMPLICITY, ILLUSION, AND SURVIVAL

It's midnight in America, and we're all trying to figure out what just happened in the darkest parts of our public imaginary. The rise of Donald Trump and Trumpism has revealed a major rift, not just in political life, but in the whole symbolic order. It has also uncovered the rot at the core of American exceptionalism and its barely submerged psychopathologies of racism, sexism, nationalism, and xenophobia. These things have obviously been a part of America from the beginning, but are manifesting and being manipulated differently now.

As a student of images and of how images are used to affect public opinion and public sentiment, I watched in dismay as a whole new kind of iconopolitics, largely at the service of these psychopathologies, captured our screens. We created new platforms for communication, and then watched helplessly as they became over-whelmed by expressions of hatred and fear. As John Berger wrote in his intro-duction to my book *Between the Eyes* in 2003, "Any tyranny's manipulation of the media is an index of its fears." Trump's fears are constitutive. Everything he says and does comes out of fear. Everyone is a threat, and so must be constantly reassessed and countered.

Political speech, especially, was transformed by this. As it happened, I had a prime seat inside the machine for making political speech and images as this latest manifestation bloomed. I attended both the Republican and Democratic conven-tions in the summer of 2016, in Cleveland and Philadelphia, as a culture spy, with floor passes.

After the conventions, I continued to write periodic dispatches on the campaigns, the debates, and the election. After Trump became president, I began to write a different kind of response—in the voices of the regime, and in the voices of com-plicity. One of the most frequently uttered sentiments by commentators over the past three years has been, "Well, I can't get into the mind of Trump, but …" Yet I proceeded with the realization that getting into the mind and language of Trump was exactly what was needed if we were to understand what was happening to us.

Recent sweeping changes in the way words and images are produced and received certainly helped make the current political situation possible. Remove social media from the equation, and everything changes. The changes in our communications environment that have taken hold over the past fifteen to twenty years remain largely unscrutinized because we are still enthralled and entranced by the mechanisms at play. Our fascination with and fealty to these devices and apparatuses keep us from asking fundamental questions about them. And they are specifically designed to prevent such inquiry. They are designed to maximize attention and minimize scrutiny. Trump understood this, instinctually, and modeled his behavior on that axiom.

This is the environment that Putin's Russia targeted, infiltrated, and manipulated in the 2016 campaigns. However Trump himself fares in the constitutional crisis, the mechanisms that made all of this possible will not suddenly disappear. The damage done to the symbolic order—to words and images and their purchase on the Real—will take a long time to repair, and the effects of this assault on the public imaginary will be far-reaching and long-lasting.

Trump has spent his entire life conforming to, trading on, and celebrating our worst cultural tendencies. Coming of age in the 1960s, he represented the counter-counterculture. He embraced the excesses of big money and bad politics in mainstream American culture. His call to Make America Great Again is an appeal to erase the political and cultural changes that resulted from the countercultural push of the 60s, in civil rights, social justice, and multiculturalism.

The underlying collusion that fueled the rise of Trump resulted from the "secret agreement" made by voters at the ballot boxes and consumers in front of TVs and the screens of our other devices to set aside the social contract. In his first debate with Stephen Douglas in Ottawa in 1858, concerning the state's approach to slavery, Abraham Lincoln said, "In this and like communities, public sentiment is everything. With public sentiment, nothing can fail; without it nothing can succeed."[1] It is difficult to believe that a failed real estate developer, reality-TV star, and con man has turned out to be one of the most brilliant manipulators of public sentiment in American history, but it is nevertheless true. And the sooner we come to terms with that fact, the better chance we will have to survive it.

In the year 2000, the artist Jon Winet invited me to collaborate with him in his ongoing multimedia project built around the quadrennial presidential campaigns. He had been getting good press credentials to get onto the floor of the conventions as a photojournalist since 1984, and thought he could get me in as well. He would take the pictures, and I would write daily dispatches from the floor.

The first time I walked onto the floor of the Republican National Convention in Madison Square Garden in August of 2004, I realized that I had walked into a machine for making public words and images.

In 2008, I joined Jon and his photographer colleague Allen Spore inside the Pepsi Center and Mile High Stadium in Denver to see Barack Obama accept the nomination. Because of other commitments, I sat out the 2012 conventions. But when it became clear that Donald Trump was going to be the Republican nominee for president in 2016, I knew I had to be there. Whatever happened, this was going to be something extraordinary in the realm of iconopolitics, and I wanted to see it up close.

I was not disappointed. Being inside the convention halls that year in Cleveland and Philadelphia was both exhilarating and terrifying. I want to thank Jon Winet and Allen Spore, for getting me inside the machine for the production of public words and images, and especially for getting me back out.

And I am grateful to Magnum photographers Susan Meiselas and Peter van Agtmael, who have graciously joined me here to provide a visual counterpart to the writing.

PART I
A COLD FEAR

DISPATCH 1:
IN ADVANCE OF THE ORANGE ACID

ON THE ROAD, FRIDAY, JULY 15, 2016, 5 PM.

As we begin to pack up the Jetta for the trip to Cleveland, an ISIS-inspired lone loser has devastated Nice by turning driving into terror, after the shooter in Dallas turned cop-killing into terror, and speculations abound about what particular kind of terror will hit Cleveland this week.

We credentialed ones will certainly be outgunned, as weapons are banned from inside the Q, but not on the streets outside, where Ohio's open carry law is going to make it difficult to tell the Bad Guys with Guns from the Good Guys with Guns. Welcome to Trumped America, where everything is permitted and nothing is required. How do you like it so far?

Tim Tebow's in, Tim Tebow's out. Don King's in and out. Sarah Palin's cagey. Mike Pence is almost definitely in. It's not Mike Ditka's kind of thing. You're all fired but me. I'm the new Decider. I do it with tweets. I'm going to win so much you're going to get sick of me winning. I'm winning good, aren't I, Mommy? Melania? Ivanka? I'm big and strong and good and winning, and everything is fine. Everything is tremendous. Believe me. Remember that.

Five hundred Cleveland police, 2,500 officers from California, Texas, and Florida, and 3,000 Department of Homeland Security personnel. An extra $50 million for convention security. Jails for 975 arrested protesters, 12 judges working 20-hour shifts in courts open 20 hours a day. Two thousand sets of riot gear, 2,000 steel batons, 24 sets of bulletproof vests and helmets, 10,000 sets of plastic handcuffs.

For the first time in their history, Amnesty International is sending human rights observers to the conventions in the U.S. CNN said, "The multinational human rights organization typically sends monitors to document elections, transitions of power and public unrest in countries around the globe riven by civil war or ruled by autocrats."[2] This year, Amnesty will have to decide whether to concentrate on the coup in Turkey or the one in Cleveland.

Permitted protesters in Cleveland include the Westboro Baptist Church from Kansas ("Thank God for Dead Soldiers"), and Andrew Purchin, from Santa Cruz, California (event name: "The Curious End to the War Against Ourselves"), in addition to Blood & Honor and Bikers for Trump.

"To get back to the warning that I've received, you may take it with however many grains of salt as you wish, that the orange acid that's circulating around us *is not specifically too good*. It's suggested that you do stay away from that. Of course, it's your own trip, so be my guest. But please be advised that there is a warning on that one, okay?"[3]

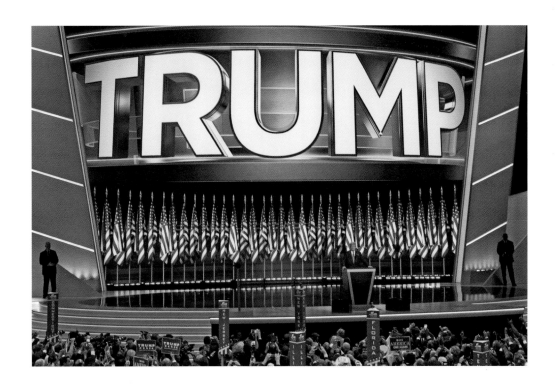

Donald J. Trump speaks to the RNC.
Cleveland, OH. 2016. Photo by
Susan Meiselas, Magnum Photos.

DISPATCH 2:
NEW SHOOTINGS

CLEVELAND, SUNDAY, JULY 17, 2016, MIDNIGHT.

An hour and a half into our ten-hour drive from the Hudson Valley to Cleveland, Michael Taussig called with news that three police officers had just been gunned down in Baton Rouge. He was worried that this might affect proceedings in Cleveland, and felt as if everything could break down into open warfare.

As we drove, facts about the shootings came slowly to light. Eventually, it was revealed that the shooter was a Marine veteran of the Iraq War who had been in Dallas three weeks ago, and had posted a video on YouTube proclaiming that protesting was not enough, and that eventually, "we have to fight back."

When we arrived in Cleveland, the local nightly news reported that it was "a pretty quiet night in Downtown Cleveland," with few protests so far. The loudest sounds came from an invitation-only RNC welcome event at North Coast Harbor dubbed "Rock the RNC in CLE," where 12,000 VIPs enjoyed a Three Dog Night reunion and guests had access to "the world's only Rock & Roll Hall of Fame." A fireworks show ended the evening.

During the nightly news, the "Do Your Part—Stop Hillary" ad that the National Rifle Association made in support of Donald Trump aired. In response to the new shootings in Louisiana, the head of one of the largest police unions in Cleveland asked Ohio Governor John Kasich to suspend Ohio's open carry laws for the four days of the convention, but the governor, who has made it clear he will not attend the convention, refused.

The schedule for the convention has finally been released by the Trump people. The theme for the first day of the convention is "Make America Safe Again," and featured speakers include Melania Trump, Rick Perry, Rudy Giuliani, and *Duck Dynasty*'s Willie Robertson.

The last headline I saw tonight was "2 People Shot at Stop the Violence Party in Euclid."

DISPATCH 3:
ALPHA MALE IN THE MIST

CLEVELAND, REPUBLICAN NATIONAL CONVENTION,
MONDAY, JULY 18, 2016, 11:55 PM.

Doctor, the conversion therapy is not working. I said, THE CONVERSION THERAPY IS NOT WORKING!!!* For eleven hours today, I talked with, observed, photographed, and commiserated with hundreds of Trump supporters. I talked with people I might have grown up with in the Kansas delegation. I remembered. At the end of the day, I sat amongst Florida delegates, listening to Rudy Giuliani and Melania Trump, while the old guy sitting behind me dressed in a baggy full-length U.S. flag suit and a red "Make America Great Again" hat punctuated every bullet point by Rudy and Mel by whistling shrilly in my ear, and the woman sitting next to me screamed at the top of her lungs and shouted "Hillary for Prison," "USA, USA, USA," and "Trump, Trump, Trump." As we exited the Q, I felt like I'd been assaulted by an ugly mob of ducks.

As I recall, Prime Time began with the *Duck Dynasty* guy, wearing his signature flag headband and talking about how Trump would be good for his business and God bless that. Sometime later came the woman whose son was killed in Benghazi, soldiers who fought in Benghazi, culminating in a film about Benghazi. Then there were a number of women and Black men whose sons and daughters had been killed by illegal immigrants. It turns out that one person is responsible for all of these deaths: Crooked Hillary. And Obama, of whom Hillary is a clone. I don't know why people whose loved ones have been cruelly killed by Obamacare were not included. Perhaps tomorrow.

Politics is partly about grievances, and being aggrieved, and the litany of these tonight was long and heartfelt. Late in the day, but before the switch to prime time, an internally aggrieved group, the Dump Trump, Never Trump forces, staged a last-ditch effort to get a roll-call vote, to try to make it possible for pledged delegates to "vote their conscience" rather than honor their pledge to vote for Trump. I don't know if this ever had a real chance, but the protest lasted only a few minutes

* The Republican platform this year is further to the right than in previous years. It includes a wholehearted embrace of "conversion therapy."

and was quickly and decidedly quashed. In the hours after the "uprising," all of the "Dump Trump" t-shirts, hats, and signs I'd seen earlier vanished, replaced by the uniform "Trump Pence" red, white, and blue. Republicans have made their bloody bed, and now they're going to have to lie in it.

Among the speakers this first night, there were a few at the beginning who tried to get a little rhetorical distance from the nominee by concluding their remarks with something like "We'll see you down-ballot in November," but those were washed away in the blood of later lambs.

Whatever else happens, this is a fight to the finish. Either he'll win, or she'll win.

DISPATCH 4:
A COLD FEAR

..

CLEVELAND, REPUBLICAN NATIONAL CONVENTION, TUESDAY, JULY 19, 2016, 11:55 PM.

When I first heard that Donald Trump was planning to have most members of his immediate family speak on his behalf at the convention, I took this as further evidence that his campaign was running on a right wing and a prayer.

His invitations to speak had been rebuffed by a long list of celebrities, joining the unprecedentedly long list of prominent Republican politicians who had refused to set foot in Trump's arena. So, he decided to do it all himself, with a little help from the only people in the world he could still count on to lavishly praise him: his wife and progeny. It was the desperate act of a world-class narcissist.

Melania's speech Monday night went well—white Presidential dress, check; cantilevered spanx, check; *good* immigrant story, check; unreserved praise of the Donald, check, check. But then little Jarrett Hill sent out his tweet claiming that significant portions of Melania's speech had been lifted intact from the speech Michelle Obama had given in support of her candidate husband in 2008, and all hell broke loose. It was the tweet heard round the world. Those who rise by the tweet shall fall by the tweet.

The media's sudden obsession with plagiarism was a thing to behold. All suspicions about the underlying illegitimacy of Trump's successful candidacy were channeled into discussions of a speechwriter's originality. It was all anyone at the networks was talking about on Tuesday. The obsession was so strong that it carried over to tonight, when *The Daily Show* tweeted that Donald Junior's speech was also plagiarized, and one of the speechwriters came forward to say he'd merely repurposed some of his own published writing.

following pages

— RNC. Cleveland, OH. 2016. Photo by Susan Meiselas, Magnum Photos.

But something else happened tonight that is more disturbing and consequential in the long run: the emergence of a possible Trump dynasty.

First came twenty-two-year-old Tiffany Trump, daughter of Trump and his second wife, Marla Maples. Tiffany is described on her Wikipedia page as "an American heiress, singer, fashion model, and Instagram user." At the Q, she and her voluminous hair came across as part throaty 1940s femme fatale and part girl next door, making a credible contribution to the Marilyn Monroe Doctrine. Ivanka cried as her half-sister spoke.

Then came Ivanka's brother, Donald J. Trump, Jr. He took the stage like the groomed scion he is—supremely confident, forceful, and at ease with his privilege. When he made a mistake about "pouring sheetrock and hanging cement," it didn't hurt him because he shrugged it off with a perfectly timed and nuanced laugh. His speech was remarkably cogent and persuasive, as if someone had taken his father's rants and distilled them into sense. His temperament was also refined, as if his father's bullying hateful speech had been run through a less aggrieved and resentful filter. Donald Junior was good—Kennedy good.

Tonight at the Q, Paul Ryan looked like the past, and Donald J. Trump, Jr., looked like the future.

Until now, I have not been truly afraid of Donald Trump, because I've never really believed that he could, finally, be elected. There are just too many negatives for too many voters. But tonight, watching his heir rise, and watching the effect his son's speech had on the crowd, how their faces and body language were transformed, a cold fear washed over me.

DISPATCH 5:
TRUMP CITY

....................................

CLEVELAND, REPUBLICAN NATIONAL CONVENTION, WEDNESDAY, JULY 20, 2016, 5 PM.

As far as we can tell, projected protests at the Republican Convention have not materialized—at least not yet. On the first day of the convention, we walked out of the Renaissance Hotel in Cleveland into the new Public Square, and found . . . nothing. A few groups of three or four people each were scattered around the square, holding signs and talking amongst themselves. There was a stage at one end of the square, and people had signed up to speak from the podium at designated times. We listened for a while to a woman describing the death of her sons in a police shooting. She was impassioned and clear as she called for peace in Cleveland, but there didn't seem to be any question about peace on the lips of dozens and dozens of armed, uniformed, be-Kevlared peace officers looking on. A little further on, a group of them warily eyed one backwoods citizen with an ancient assault rifle slung across his back, asserting his legal right to carry. He didn't need to speak.

Before we entered the ultra-High Security Zone of Quicken Loans Arena yesterday, we paused to observe the small "protest zone" outside. An earnest man with a bullhorn and a speech defect exhorted the passing delegates to accept Jesus Christ as their personal savior, enacting an extreme case of preaching to the choir. Behind him stood a little group of Trump supporters with a sign that read "Trump's Wall Brigade." These "protesters" were protected by a phalanx of armed police officers.

The entire area of downtown Cleveland hosting the convention, from the Tower City–Public Square area to Quicken Loans Arena to the far-flung Media Center, built into a converted parking lot/bunker under the Cleveland Convention Center, has been scrubbed of all civilian presence. There is no one here but the credentialed and the cops.

Within this Green Zone—a highly fortified encampment carved out of the city—a network of heavy metal grid fencing has been built, ten feet high, to make it impossible for vehicles or pedestrians to move freely within the Zone. When you enter the Zone, you're theirs.

The armed officers in the security detail that checks every bag as we pass through three levels of metal detection are totally dedicated to their task. No water bottles, no umbrellas, no whole fruits.

Inside the arena, there is an extensive network of Secret Service operatives who stand at all entrances and passageways, looking for trouble. And there are volunteers in neon yellow hats who control their areas completely, looking for any sign of noncompliance. Their authority is absolute.

The only other time I have seen this level of security at a political convention was at the Republican National Convention in Madison Square Garden in 2004. In that case, there was still plenty of city for us to march in, and 500,000 of us did.

The security planners for the Republican Convention in Cleveland were prepared for Armageddon, and it didn't happen, or hasn't happened yet.

DISPATCH 6:
CRACKING THE BLACK MIRROR

**CLEVELAND, REPUBLICAN NATIONAL CONVENTION,
WEDNESDAY, JULY 20, 2016, 11:55 PM.**

By the time "actress and avocado farmer" Kimberlin Brown took the stage on Tuesday night ("for all you guacamole lovers!"), it had become clear that something had gone terribly wrong with the speaker selection process leading up to Cleveland. And when people bolted for the exits immediately after Melania's speech on Monday night, leaving Lt. General Flynn and all who followed to speak to an empty house, it was clear that planning the order and sequence of speakers had also gone wrong. But the larger problem was foreshadowed when Senate Majority Leader Mitch McConnell ("the Turtle") was roundly booed when he took the stage to announce the nomination of Mike Pence to the office of vice president.

Tonight, these problems were magnified and concentrated in a literal and figurative breakdown of the images being projected. The two key moments occurred when Eric Trump and Ted Cruz spoke. Eric Trump, the number-two son, inherited a high unlikeability quotient from his father, and Cruz had already broken the record for unlikeability on a massive scale in the primaries.

Eric Trump's speech itself, and his technical delivery, were not bad, proving that money can't buy everything, but it can buy really good speechwriters and speaking coaches. But his face betrayed him, revealing the underlying meanness and preternatural arrogance that drive him. We've all seen that kind of face before, on autocrats and dictators throughout history.

In this instance, the contradictions between what he was saying and what his face and body were telling us seemed to cause an actual breakdown in the image. The images on the video wall behind him began to black out, square by square, sputtering maniacally to the cadences of his speech.

following pages
— Indiana Governor Mike Pence, VP nominee,
speaks to the RNC. Cleveland, OH. 2016.
Photo by Susan Meiselas, Magnum Photos.

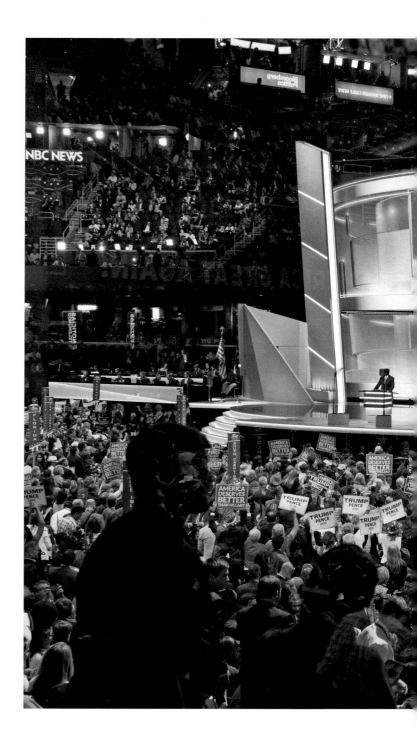

Observing cameras cut away to pick up Eric's father, watching the debacle with a strange mixture of pride and fury. He was proud of his son, but whoever was responsible for the maintenance of the image was failing, and would be fired.

Eventually, the image behind Eric Trump failed entirely and went blank, so the last part of his speech was delivered in front of a black mirror. The floor lights in front cast his shadow on the black screen, his arms rising and falling like infernal wings. Without the images on the screen, his words were revealed in all their desuetude. The dynasty narrative was broken.

As Cruz delivered his snub speech, and the shouts and boos of the assembled faithful rose to drown him out, the image behind him began to disintegrate. And this confluence of chaos suddenly achieved a larger significance, mirroring the ultimate breakdown and dissolution of the Republican Party.

What has been proven so far at this convention? That there are enough Trump supporters, rabid or reluctant, to fill, or nearly fill, a large arena. The question remains: Are there enough of them to elect a president? It is a part of the ethos of this movement *not* to reach out beyond the hard core, and *not* to do anything to appeal to those who don't share your convictions. So far, there is no ecumenical side to the movement, and the fault lines are becoming more and more visible. Even Mike Pence can't change that in time.

DISPATCH 7:
BEFRIENDING THE BEWILDERED

...

CLEVELAND, REPUBLICAN NATIONAL CONVENTION, THURSDAY, JULY 21, 2016, 11:55 PM.

Donald Trump just finished his acceptance speech at the convention. With this speech, translated from the original German (thank you, Molly Ivins) onto tele- prompters, Trump swept away all the tentative attempts at unity and understand- ing and diversity, most of them offered by his own family, over the past four days. He took all the vitriol and pomposity and demagoguery spewed in his primary campaign rallies and turned them up a notch. This speech was fueled by xeno- phobia, nativism, protectionism, and rank nationalism. It used catchwords and phrases from the history of these tendencies: "Make America Great Again" from Ronald Reagan, "America First" from Charles Lindbergh, "Law and Order" from Barry Goldwater and Richard Nixon, and "I am your Voice" and "The time for action has come" from Mussolini.

He began the speech with a little humility and a little humanity, but then started to veer off. The message rapidly became: You are in danger. We are all in danger, and the danger is increasing, both domestically and internationally. The danger comes from the outside, from foreigners—immigrants and terrorists, or immigrant ter- rorists. You need me to protect you. I am the only one who can protect you. "I will restore law and order to our country. Believe me. Believe me." "On January 20, 2017, safety will be restored." "I will build a Great Border Wall."

This litany of fear was larded with attacks on his opponent, Hillary Clinton. She does not understand the danger, and so is not fit to lead. She is weak. She must not only be defeated; she must be imprisoned for her "great crimes."

The rest of the opposition is led by "censors, critics, and cynics" in the media and in politics, who said from the beginning that Trump didn't have a chance. "We love defeating those people."

As he spoke (the speech lasted an hour and fifteen minutes; the longest accep- tance speech since Nixon's in 1972), I scanned the faces of his family. Melania was completely inert and robotized. Eric was gleeful. Ivanka and Donald Junior had

looks on their faces that I could not read. But of course, they've all been hearing this demagoguery regularly for a long time, and have accepted it in their own ways.

At least now things are clear. The conservatives and reasonable Republicans that have rolled over for Trump must now know exactly what they're supporting, and what the election of Trump would mean for America and the world.

DISPATCH 8:
PAY, PAL
.........................

CLEVELAND, REPUBLICAN NATIONAL CONVENTION, FRIDAY, JULY 22, 2016, 11:55 AM.

One of the many future horrors of a Trump presidency glimpsed last night was an unholy alliance between Trump and Silicon Valley. Unctuous tech entrepreneur Peter Thiel, looking and sounding like the ghost of Trump's mentor Roy Cohn, said, "I build things. So does Donald Trump. And we need to rebuild America."

Thiel cofounded PayPal, and invested early in Facebook (he's the character in *The Social Network* that writes Mark Zuckerberg a half-a-million-dollar check to get him to betray his partner). He now runs Palantir Technologies (the company is named after the seeing stones in *The Lord of the Rings*), a mass surveillance software company with a lot of government contracts, with the DOD-NSA, the Department of Homeland Security, the FBI, and the CIA. Their big data analysis is also used by big banks, hedge funds, and financial services firms. Palantir has been valued at $15 billion, and Thiel is its largest shareholder.

Though gay, Thiel has supported candidates like Ted Cruz who have advocated the most extreme homophobic policies, and he is an outspoken opponent of multiculturalism and political correctness. He co-authored a book about it, titled *The Diversity Myth: Multiculturalism and Political Intolerance on Campus*.

Imagine, for a moment, what would happen in America and in the world if Trump joined forces with men like Eric Schmidt, Mark Zuckerberg, Jeff Bezos, and Peter Thiel.

One of the many things Trump and Thiel agree on is their shared contempt for the free press. Trump has called the press the "world's most dishonest people," and said (tweeted): "The media is really on a witch-hunt against me." One of the planks of Trump's unofficial platform is to change the libel laws in the U.S. to make it easier for aggrieved persons to sue journalists when they don't like what they say about them.

As we know, Thiel recently secretly funded the many lawsuits intended to put web publisher Gawker Media out of business.

Trump has made it clear that the "censors, critics, and cynics" in the Liberal Media will do and say anything to keep the rigged system in place. They must be stopped.

At the Republican National Convention over the past four days and nights, the media has been tolerated, but not welcomed. Access is grudgingly given, but always within strict bounds. The bright-yellow-hatted whips on the floor, who orchestrate all images and all "spontaneous" movements and outbreaks among the delegates (and throw out all unauthorized outbreaks like the one by Code Pink activist Medea Benjamin during Trump's speech), keep a wary eye on photographers and other journalists. If they don't like how you look, you're out. My Secret Service credential has this disclaimer printed on its back: "This pass is a nontransferable, revocable license that may be revoked at any time for any reason."

Imagine this policy extended outside the high-security Q, to the world at large, under a "Law and Order" Trump presidency.

DISPATCH 9:
AGREE? REACH OUT TO ME

ON THE ROAD, CLEVELAND TO PHILADELPHIA,
SATURDAY, JULY 23, 11:55 PM.

It was only upon leaving Cleveland that I realized how utterly strange the setup there had been. We weren't actually in Cleveland; we were in Trump World, where everything was scrubbed, locked down, and managed. The rules were different there. Facts don't matter; only what you believe matters. The Enemy is all around us, trying to come in from the outside ("Build the Wall, Build the Wall"), but they're also inside, rigging the system. They're like cockroaches: turn on the lights and they run like hell. We don't want to torture and kill them, and kill their families, but we have to do it. We have no choice. We have no choice.

I am the only one who can protect you. I am the only one who can fix everything. I am the only one you can trust. I know how the rigged system works because I helped rig it. I was one of Them, but now I'm Your Voice.[4]

The security and surveillance in Trump World were so intense that a collective Stockholm Syndrome eventually set in. Even I acquired an unprecedented volubility around police officers, greeting them as if they were old friends, asking about their families, and commiserating about the heat and long hours.

Just before going through the biggest security check on the way in to the Q, everyone walked down a short section of Fourth Street filled with vendors selling Trump souvenirs—Trump playing cards, thousands of buttons, t-shirts reading "Hillary Sucks, but not like Monica Lewinsky"—preachers, comedians, impersonators, a singer-songwriter with Trump stickers on his guitar, "protesters," etc. It was a block-long display of "diversity" and "street life" for our delectation before entering the inner sanctum. Looking back on it now, I wouldn't be at all surprised if "Fourth Street" only existed on the Holodeck.

As far as I can tell, the only two spontaneous actions that happened at the Republican Convention were the two Code Pink eruptions, and both of those women were pounced on, silenced, and removed instantly. One of them was tackled and cocooned in an American flag before being carried away. The only other possible

unscripted act involved my fellow Kansan, ninety-three-year-old Bob Dole, but I'm still sorting that out.

Speaking of crusty old codgers, the one sitting next to me on the penultimate night of the convention, up on the top tier, gave me his card, reading, "Democracy won't work!" in large type, and then "51% voting to Rape, Pillage and Rob the other 49%.—Ben Franklin." And on the other side: "Our Representative Constitutional REPUBLIC. Agree? Reach out to me. Bill T. Davis." When Bill rose to leave, he leaned over and whispered in my ear, "The only three I've seen in my whole life: Goldwater, Reagan, and this one."

RNC. Cleveland, OH. 2016. Photo by Susan Meiselas, Magnum Photos.

DISPATCH 10:
A TRUMP BUMP ON BERNIE NIGHT

PHILADELPHIA, MONDAY, JULY 25, 2016, 11:55 AM.

I awoke this morning to the sounds of Democratic discord, as DNC Chairwoman Debbie Wasserman Schultz tried to speak at a Florida delegation breakfast and was jeered off the stage by Sanders supporters. Yesterday afternoon, Jon went down to the convention center to see thousands of energetic Bernie supporters march to the Wells Fargo Center in 96-degree heat. The people he interviewed, who are representative of the whole group, will have a very hard time voting for Hillary. Everything these voters say about Hillary is true, unfortunately. For them to switch and vote for her, they're going to have to set all that aside. They may do that, but they will do it reluctantly. They are officially Depressed Voters, and there are a lot of them.

CNN polls now have Donald Trump beating Hillary Clinton by five points, if the election were held today. The post-convention Trump Bump swelled to nine points with independent voters. Sixty-eight percent of voters now say they don't trust Hillary Clinton.

In what increasingly appears to be the New Normal, another mass shooting occurred in Fort Meyers, Florida, with two dead and up to sixteen wounded.

Michael Moore's blog in the *Huffington Post* on Saturday lists "5 Reasons Why Trump Will Win," including "Midwest Math, or Welcome to Our Rust Belt Brexit" (Trump will win Michigan, Ohio, Pennsylvania, and Wisconsin to put him over the top), "The Last Stand of the Angry White Man," "The Hillary Problem," "The Depressed Sanders Vote," and "The Jesse Ventura Effect." The last reason is one of the most convincing: "Finally, do not discount the electorate's ability to be mischievous or underestimate how many millions fancy themselves as closet anarchists once they draw the curtain and are all alone in the voting booth. ... Millions are going to vote for Trump not because they agree with him, not because they like his bigotry or ego, but just because they can. Just because it will upset the apple cart."[5]

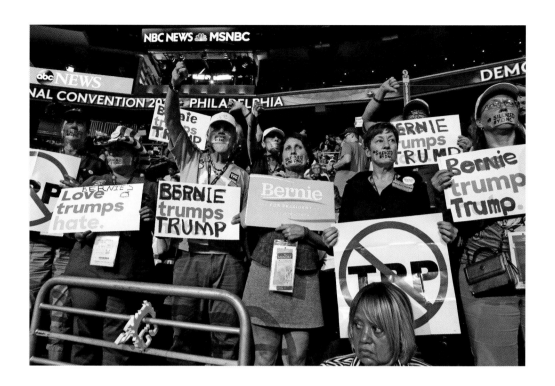

— Bernie Sanders supporters protest at the
DNC. Philadelphia, PA. 2016. Photo by
Susan Meiselas, Magnum Photos.

This is Bernie's night at the convention, and he has his work cut out for him. He likes that. This week in Philadelphia, the Democrats are going to have to wake up and get it together. If they don't, the past fourteen years of your life will hereafter be known as your neo-Weimar period.

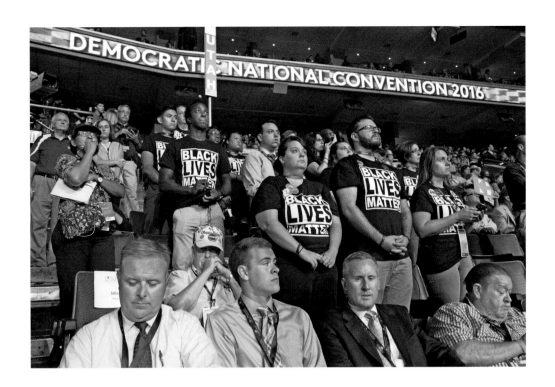

— Black Lives Matter protesters at the
DNC. Philadelphia, PA. 2016. Photo by
Susan Meiselas, Magnum Photos.

DISPATCH 11:
TROUBLED WATER
..

PHILADELPHIA, DEMOCRATIC NATIONAL CONVENTION,
MONDAY, JULY 25, 2016, 11:55 PM.

Conventions are, of course, conventional. These elaborate quadrennial pageants are designed to bring the disparate and unruly emotions and needs stirred up in the primary campaigns into line with party orthodoxy. Ideally, these underlying drives are focused and sharpened into coherent and compelling positions that can achieve enough broad popular support to prevail in a general election. The Democrats are currently behind in this process, and this is reflected in polls that show the Republican nominee up by six points.

The first half of the first night of the Democratic Convention in Philadelphia was not dissimilar to what we saw in Cleveland, from the other side. Traditional Democratic topics were broached, sometimes articulately and sometimes clumsily, by the party faithful, in a desultory stream.

Things began to come into focus when Senator Cory Booker took the stage. He began: "Two hundred forty years ago, our forefathers gathered in this city and declared before the world that we would be a free and independent nation. Today, we gather here again, in challenging times, in this City of Brotherly Love, to reaffirm our values, before our nation and the world." In the end, Booker's speech did not quite rise to the level of Barack Obama's at this convention in 2004, but it did introduce a future national leader to a larger number of Americans. It also made some of us wince at the lost opportunity of Hillary's choice of running mate. If she had taken a chance with Booker or Elizabeth Warren or even Bernie Sanders, this might already be a different kind of race.

The big donkey in the room tonight, of course, was the reluctance, or possible inability, of Bernie Sanders' 1,824 pledged delegates, and many more supporters among the 20,000 or so gathered here, to switch their allegiance and get behind Hillary Clinton. Tonight, they booed, hollered, changed Hillary signs to read "Bernie Trumps Hate," sat on their hands, and finally wept, as their champion tried to move them into the mainstream of the party. The WikiLeaks/Russian email dump that occurred on Friday, July 22, 2016 (*now* we care about your damn emails!)

proved what Sanders had claimed all along—that his campaign was discriminated against by the people who make the rules—and this stoked the feelings of betrayal among Sanders supporters to a white heat.

This first night was designed to placate, assuage, and convince them. Comedian Sarah Silverman didn't aid in this by saying their resistance was "ridiculous." It is not ridiculous to believe that things can change and to fight for it. These Bernie supporters are the future of the Democratic Party, if they have one, and the leadership needs to recognize that, if they are to survive this election.

Michelle Obama recognizes it, and she gave one of the best convention speeches of the modern era. "We cannot afford to be tired or discouraged or cynical," she cautioned, because the stakes are too high. Her argument against Trump was based on a plea for the protection of children, and she made the strongest case I've yet heard for a Hillary Clinton presidency. She also lifted the entire proceedings into a higher realm when she said, "I wake up every morning in a house built by slaves." If the Democrats don't make and distribute a stark comparison between the speeches of Michelle and Melania, aside from the plagiarism, they should be prosecuted for malpractice.

For me, on the floor tonight, the best moment happened when Paul Simon came on stage to sing "Bridge over Troubled Water" like it's never been sung before, as blue light softened the faces of the delegates and obscured the messages of competing floor signs. He was singing not just to aggrieved Bernie supporters, but to all Democrats, and even more to all eligible voters, in the hope that they will wake up and get serious about the real threat of the Trump candidacy, before it's too late.

DISPATCH 12:
BREAKING THE MACHINE

PHILADELPHIA, DEMOCRATIC NATIONAL CONVENTION, TUESDAY, JULY 26, 11:55 PM.

When we arrived at the arena tonight, a large group of Bernie supporters were protesting just outside the entrance. We learned that 120 Bernie delegates had walked out after the Roll Call vote. Jon interviewed one of these delegates, Carmen Hulbert, from Red Hook, Brooklyn. A Peruvian immigrant, she is the cofounder of Latinos for Bernie, NY, and has worked in the trenches for Bernie for over a year. When she was elected a national delegate for the Seventh Congressional District in Brooklyn, she mounted a GoFundMe campaign to raise the money for her travel to Philadelphia for the convention.

As Carmen spoke to us about what had just happened, she began to cry, out of frustration and disappointment. "The Revolution belongs to us," she said through her tears. "We started this movement, inspired by Bernie, but he chose to give our votes away, to Hillary Clinton. She is a substandard candidate, so Trump will win. I cannot vote for her."

A long double row of police officers had set up inside, to contain a growing number of angry Bernie supporters as they walked out, as if to protect the rest of the delegates from contamination.

In addition to the three extraordinary women we spoke with at the Muslim American Delegates Dinner (did you know that Philadelphia is known by some as "Muslim Town?"), this moment with Carmen Hulbert brought all the hoopla of the conventions down to earth, to the individuals whose lives are profoundly affected by what goes on here.

Inside the hall, the litany against Trump and for Hillary continued. The Mothers of the Movement, comprising the mothers of Trayvon Martin, Jordan Davis, and Sandra Bland, appeared, speaking with force and clarity about their reluctant membership in this movement when their children were killed. Senator Amy Klobuchar of Minnesota introduced Ima Matul, from Indonesia, who had been commandeered

into sexual slavery. Cecile Richards, president of Planned Parenthood, spoke about the real and present danger of returning to the time before *Roe v. Wade*.

The underlying theme tonight, building on Michelle Obama's speech last night, was the importance of this election for children, who cannot vote.

There were moments of celebrity levity, too. Elizabeth Banks did a great robotic imitation of Trump's fog machine entrance. Lena Dunham said Trump had rated her "A possible 2," and America Ferrera added, "And he rated me a rapist." Meryl Streep greeted the crowd with, "We've got some fight left in us, don't we?" And Alicia Keys concluded her set with "Vote for Hillary Clinton, because love will always win."

But the real star tonight was Bill Clinton. When he came out on stage and did a little dance skip step just before reaching the podium, the crowd erupted. When they finally quieted down, he began with the line, "In the spring of 1971, I met a girl." As he told the story of his courtship of and marriage to Hillary Rodham Clinton, the whole arena changed. This massive space, filled to the brim with 25,000 excited activists, suddenly became Bill's lounge. The temperature changed. Bill Clinton broke the Machine.

Bill Clinton talked about Hillary the way previous First Ladies have talked about their husbands. It was a transgender speech, and he pulled it off beautifully. This is a man who always knows exactly who his intended audience is, and tonight it was married women, especially suburban married white women, the group that Hillary needs to win and win big.

He called Hillary "The best darn change-maker I've ever met in my entire life." He compared her to Bobby Kennedy. He rubbed off all the hard edges of Hillary and made her into what everyone hoped she would be, and we believed him. We wanted to believe him.

Her biggest problems right now are Trust and Likeability, and Bill moved the needle. He said the Republicans couldn't run against the real Hillary, so they've created a different one, a cardboard cutout image. He said it came down to this: "One of them is real, and one is made up. Luckily, you've nominated the real one." It was the most astonishing bit of political sleight-of-hand I've seen in years.

I don't like Bill Clinton; I never have. I still blame him for moving the Democratic Party to the center-right during his presidency—of giving up too much to stay in power when I didn't think he needed to. But tonight, I have to say it was a pleasure to watch a real pro work. He loves speaking and connecting with an audience, and they love him back. He told a compelling, believable story and created a different image of Hillary.

Unfortunately, at the end of the night, Hillary appeared on the giant screen, "Live from New York," and spoiled the image that Bill had so masterfully created. She appeared wooden and awkward, even as she received the tumultuous applause. Because she apparently couldn't hear the applause and screams of the crowd in the arena, she didn't respond to them, and her timing was all off. Once again, she seemed distant and aloof, even while surrounded by laughing girls and women. If only this change-maker could somehow change her own image.

following pages
— DNC audience welcomes Hillary following
Obama's speech. Philadelphia, PA. 2016.
Photo by Susan Meiselas, Magnum Photos.

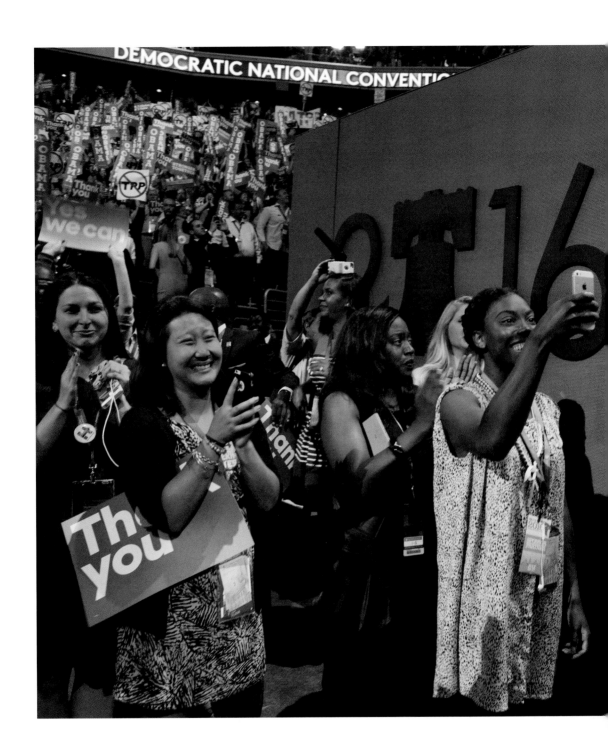

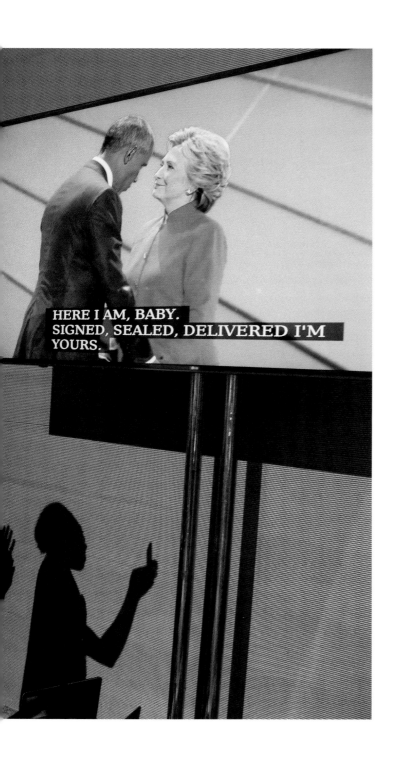

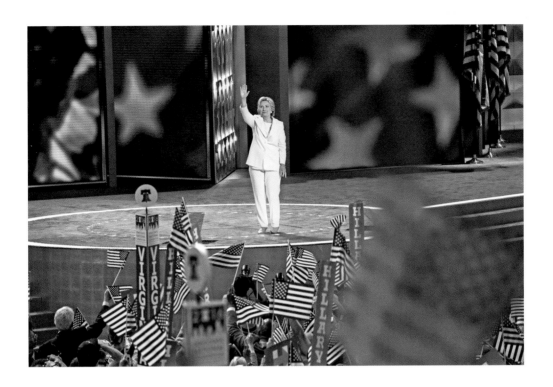

— Hillary Clinton at the closing ceremony of
the DNC. Philadelphia, PA. 2016. Photo by
Susan Meiselas, Magnum Photos.

DISPATCH 13:
DON'T BOO, VOTE

If Hillary Clinton is elected president of the United States in November, she will have Barack Obama's speech tonight to thank for it. Historians are already saying this was the most impressive speech in history by a sitting president endorsing a preferred successor.

Obama began by noting that he had addressed this convention for the first time twelve years ago tonight. What he didn't say was that he has given amazing, stirring speeches at every subsequent Democratic convention over that time period. But this one was an extraordinary culmination.

Tonight's speech, which ran about fifty minutes, began slowly and built in intensity to an explosive conclusion. The president accomplished a number of related goals in this one speech. First, he made a singularly effective argument for electing Hillary Clinton. He reiterated that she is the most qualified candidate for president in history ("more than me, more than Bill, more than anybody"). He said that no one really knew how hard it was to be president until they sat behind the desk in the Oval Office, and that "she hasn't been behind the desk, but she's been in the room." He added, "she hasn't been on the sidelines, criticizing, she's been in the arena, fighting, for forty years."

He eviscerated Donald Trump with cruel precision. His tone resembled the one he used when he roasted Trump, to his face, at the White House Correspondents' Dinner in 2011. In Philadelphia tonight, he presented the Donald as the small man he is. He said, "Donald is not really a plans guy. He's not a facts guy either." "He's betting that if he scares enough people, he'll score just enough votes to get elected." But then he broadened the critique, to show why what Trump is selling is actually against everything America stands for: "The American Dream is something no wall will ever contain." And then came the *estocada*: "We don't look to be ruled."

Obama also summed up his time in office and defined his legacy in clear and forceful terms. He elaborated the "faith in America," in "this great experiment in

self-governance" that has guided him throughout his presidency, and he expressed an unlimited belief in the strength and durability of the American people.

At the end, he spoke directly to the people in the room. These people are the foot soldiers of the electoral process. They're the ones who do the hard work to get out the vote, and they've been doing it, for Bernie and Hillary, for a long time now. Obama spoke to persuade the Bernie supporters and shore up the Hillary ones. They are tired, and they need to be reinvigorated for the tough 100 days to come. He flattered them, he inspired them, and he honestly thanked them.

He said the only thing that kept him going for the past eight years was them, the American people, who stayed with him and encouraged him. "Democracy isn't a spectator sport," he said. "You've got to get in the arena and fight."

And a final plea: "I ask you to carry her just like you carried me. I'm ready to pass the baton."

And then suddenly she appeared, from the wings, as if by magic, and finally looked radiant and relaxed, and the two embraced warmly. That image just might get this ultimate insider elected after all.

DISPATCH 14:
REALITY TUNNEL

..

PHILADELPHIA, FRIDAY, JULY 29, 2016, 11:55 AM.

On the morning after Hillary Clinton accepted her party's nomination for the presidency, Donald Trump is saying, "I watched them last night, and they're not talking about the Real World," and Fox News is saying something similar: it was nice, but the world they're talking about is not Real. Over the last four days, in a myriad of ways, Democrats have said the same thing about the Republicans.

The coming campaign, over the next 100 days, is not going to be about competing policy proposals and plans, but about the nature of Reality. It must only be a matter of time before people begin to pepper their political speeches with references to Plato's Forms and Kant's the "thing itself," and the noumenal world as opposed to phenomenal knowledge.

Or perhaps someone will recover the term Timothy Leary coined in the 1970s, "reality tunnel," to refer to the way each person constructs a view of the world according to her or his experiences and beliefs. The idea was developed further by Robert Anton Wilson, who said, Trumpishly, "reality is what you can get away with." In the book Leary and Wilson wrote together, *Neuropolitique*, they say: "The gene-pool politics which monitor power struggles among terrestrial humanity are transcended in this info-world, i.e. seen as static, artificial charades. One is neither coercively manipulated into another's territorial reality nor forced to struggle against it with reciprocal emotional game-playing (the usual soap-opera dramatics). One simply elects, consciously, whether or not to share the other's reality-tunnel."[6]

Both parties are currently saying "not." So the coming election, perhaps more than any other in history, is going to be an ontological referendum. And the two political conventions we have just witnessed have been ontological catalogues, limning two very different views of reality.

Last night in the Wells Fargo Center in Philadelphia, the Democrats framed the conflict as that between Love & Hate, and between Hope & Fear. Bernie Sanders supporters staged one last-ditch protest against Hillary's hawkishness, trying

to shout down the assembled Generals with chants of "No More War, No More War," but their cries were invaded by and dissolved in the competing three-syllable chants of "USA, USA" and "Hillary, Hillary." If there is to be a Third Way this time, it will be left to the Libertarian and Green candidates to carry it forward.

Conservative commentator David Brooks, who I kept running into in Philadelphia, wrote a brilliant column last night for the *New York Times*, pointing out that Donald Trump has figured out "an ingenious way to save the Democratic Party," by abandoning patriotism and allowing Democrats "to seize that ground." "If you visited the two conventions this year," he wrote, "you would have come away thinking that the Democrats are the more patriotic of the two parties—and the more culturally conservative."[7]

Brooks concluded that the Democrats had a better convention than the Republicans, with better speeches and a much more substantive and coherent program. "But," he cautioned, "the normal rules may no longer apply. The Democrats may have just dominated a game we are no longer playing."

As I watched Hillary on stage last night, resplendent in a glowing white suit before white stars on a blue ground, with the capacity crowd enthusiastically waving their assigned signs and sign-sticks, I thought that the epic change we're going through, from written and spoken language to the image, and from policy to perception, is making a quantum leap in this campaign, on both sides. Under the old rules, insight and thoughtful policy proposals mattered. In the New World of tweets and leaks and bombast and bluster, all that matters are the images projected on the walls of your own particular Reality Tunnel.

DISPATCH 15:
WIKITRUMP?

NEW YORK, SUNDAY, JULY 31, 2016, 11:55 PM.

I understand why Vladimir Putin would want to do anything he can to put Donald Trump in the White House, because a Trump presidency would fuel a resurgence of Russian aggression on the world stage. Trump's campaign manager, Paul Manafort, had already attempted a complete makeover for Putin surrogate Viktor Yanukovych, before the former prime minister had to flee from Ukraine to Russia to avoid a newly incensed population in Ukraine. Manafort's advising of Yanukovych ended badly two years ago, but the Trumpmeister's business dealings in Russia and Ukraine continue. There's no sense in letting a stinging political defeat interfere with one's own personal financial interests.

What I don't quite understand is Julian Assange's position. The leak of thousands of Democratic National Committee emails hacked, presumably, by the Russians, on the eve of the Democratic Convention in Philadelphia was obviously intended to harm the Hillary Clinton campaign, but to what end? To give a last boost to Bernie Sanders' supporters at the convention? Or to help ensure an eventual Donald Trump victory?

Assange had announced the coming Clinton leak back in June. When he was asked then if he'd prefer Trump as president, he replied that what Trump would do as president was "completely unpredictable," whereas we know that Hillary would be a liberal war hawk and continue what Assange sees as her attacks on freedom of the press. He also views her as a personal foe.

The timing and method of the release of the DNC emails drew a tweeted rebuke by Edward Snowden on Thursday: "Democratizing information has never been more vital, and @WikiLeaks has helped. But their hostility to even modest curation is a mistake." Assange responded within an hour and a half, impugning Snowden's motives: "@Snowden. Opportunism won't earn you a pardon from Clinton & curation is not censorship of ruling party cash flows."

Meanwhile, Tony Schwartz, the ghostwriter of Trump's 1987 book *The Art of the Deal*, which sold over a million copies and earned its author and subject millions

of dollars in royalties, has come out to decry the book and the Real Trump he discovered in the process of writing the book. In an interview with Jane Mayer for the *New Yorker*, published on July 25, Schwartz said, "I genuinely believe that if Trump wins and gets the nuclear codes there is an excellent possibility that it will lead to the end of civilization."[8]

DISPATCH 16:
MY NEW ORDER, UP & DOWN
..

NEW YORK, MONDAY, AUGUST 1, 2016, 3:00 PM.

On Friday, Donald Trump had to be rescued by the Colorado Springs Fire Department when an elevator at a resort there stalled between the first and second floors, trapping ten people inside. Officers lowered a ladder down to the passengers from the hatch in the roof. There was no word on how Trump reacted to this emergency, but it was reported that earlier that day he had criticized the Colorado Springs fire marshal for limiting the number of people allowed into one of his rallies.

Most of the news yesterday focused on Trump's splenetic response to the father of Capt. Humayun Khan, a Muslim army captain who was killed in action in Iraq. Khizr Khan's speech last Thursday at the Democratic Convention called Trump out for having sacrificed nothing and for being ignorant of the contents of the U.S. Constitution. Trump tweeted that the elder Khan was wrong to stand up in front of millions of people and criticize him. In a later interview, he intimated that Khizr Khan's wife, Ghazala, who stood silently by him on stage at the convention, didn't speak because she may have been prohibited from doing so by Muslim mores. Ghazala replied to this insult in an editorial in the *Washington Post*, saying that she did not speak because she could not talk about her dead son without being overcome with emotion. A number of Republican leaders reacted negatively to Trump's attacks on the Khans yesterday.

Today, John McCain released a carefully worded statement about the incident, rebuking Trump: "While our party has bestowed upon him the nomination, it is not accompanied by unfettered license to defame those who are the best among us."[9]

Like Trump's earlier claim that a federal judge from a military family could not be fair in his handling of a suit involving Trump because of his Mexican heritage, the Khan Affair may be a turning point in the discourse of the campaign. When the rhetoric of right-wing talk radio and reality TV comes up against the rhetoric of mainstream media, the former doubles back on itself, retweeting into solipsism, and, in this case, exposing the lengths to which Trump's naturalized prejudice against people of Mexican descent and Muslims causes him to make other bad choices.

DISPATCH 17:
BIG STUPID DATA
..

NEW YORK, MONDAY, AUGUST 1, 2016, 5 PM.

On the last night of the Democratic Convention in Philadelphia, after the balloons dropped and the music died, I was sitting in the press tent, cooling my hot heels, when I saw Nate Silver come in, with a cell phone glued to his ear, pacing from one end of the tent to the other, listening and looking very worried indeed. And well he should. He's the current Data Master. Americans depend on him to tell them what's up and what's going to happen politically, and the numbers aren't cooperating.

That's because the fear and hatred that's driving the Trump bump are difficult to measure using the current instruments. Nixon called them the Silent Majority for a reason. They don't express their opinions publicly, so the methods of public opinion polling don't work very well on them. They are the counter-counterculture. They hate those elite know-it-alls who talk about things.

Now, four days later, Hillary Clinton has received her post-convention bounce of about four points, twice what Donald Trump received after his convention, but that's cold comfort to Democrats, because this bump is barely beyond the stated margin of error of three points. Nobody I've talked to in the Democratic Party understands why her lead is not greater, over a candidate who seems destined to self-destruct, and who continues nearly every day to make rookie mistakes and say inane and insane things that would sink most campaigns. What does a girl need to do to get a real bump over this dickwad?

The data suggest that Clinton is in trouble with a group that comprised nearly half of all voters in 2012: white people without a college degree. Among this group, Trump leads 60 percent to 30 percent in most polls, and 70 percent to 30 percent in some. The spread is even greater among white men without degrees. The Weapons of Mass Destruction in the coming election are White Men without Degrees.

It took the candidacy and election of our first Black president to reveal just how much racism still guides our political life, and the candidacy of our first woman president is revealing just how misogynistic American society still is.

If only men voted in the coming election, Trump would win. If only white people voted, Trump would win. And if only people over sixty-five voted, Trump would win. So, if you're not a man, not white, or not over sixty-five, the future of American democracy is in your hands. Please don't drop it.

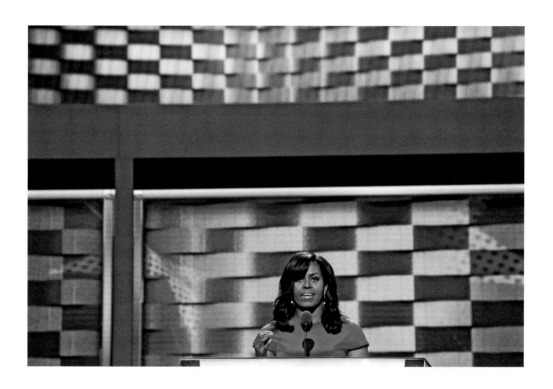

— Michelle Obama speaks at the DNC.
Philadelphia, PA. 2016. Photo by
Susan Meiselas, Magnum Photos.

DISPATCH 18:
SIMONE WEIL, T. J. CLARK,
AND BERNIE SANDERS' GRIMACE

NEW YORK, TUESDAY, AUGUST 2, 2016, 3 PM.

A political party is a machine for producing collective passion.

Collective passion is an infinitely stronger impetus to crime and lies than any individual passion.

If a single collective passion takes hold of a country, the entire country is unanimous in crime.

At the moment when a people becomes aware of its will and expresses it, there can be no collective passion.

Parties are organisms that are publicly and officially constituted to kill the sense of truth and justice in our souls.

Almost everywhere—and often for purely technical problems— the operation of taking sides, of taking position for and against, has replaced the obligation to think. This leprosy of the mind began in political circles then spread throughout the country to almost all thinking. It is doubtful that we can cure this disease, which is killing us, if we do not start by abolishing political parties.

Simone Weil, *Note on the Abolition of All Political Parties*, translated by Ames Hodges (Semiotext(e), 2014); originally published in Paris in 1957, but written in the summer of 1943, just before Weil died

It is one thing to have an optimistic (or pessimistic) view of capitalism's ability to weather the storm blowing from working-class Britain, another to underestimate the system's endogenous vulnerabilities. What hap- pened in 2008 will happen again. The break-up of the eurozone is one step nearer, the question now being whether it will be "managed" from New York and Berlin or plunged into pell-mell.... The political question therefore is this: could there be a future circumstance in which such a moment of capitalist crisis, or sequence of moments, none of them "final," could be greeted, in various nation-states ... by the beginnings— the first steps in a long reconstruction—of a minimal anti-capitalist resistance?

T. J. Clark, "Where Are We Now? Responses to the Referendum," *The London Review of Books*, July 14, 2016

DISPATCH 19:
MIDNIGHT IN DAYTONA
..

NEW YORK, WEDNESDAY, AUGUST 3, 2016, 5 PM.

Watching the Clinton Political Machine begin to go to work on The Little Dema-gogue Who Could is a thing to behold. The little-handed bully with the funny hair may fold up like the cheap seat he's always been.

It was one thing to pull off an unlikely victory in the Republican primaries by using a mixture of Old Ideology (xenophobia, racism, sexism, and nationalism) and New Media (Right Wing Talk Radio, Reality TV, and the Alt-right and Alright Internet and Twitterverse) to confuse and ultimately take down seventeen self-destructive candidates, propped up by a Mainstream Media hungry for Red Meat and twenty-four-hour ratings. But this is the *Clintons*, man.

They were triangulating and DLC-ing their way into power when you were still a grasping Democrat-in-waiting. Over the past four decades, they've built a political machine that eats punters like you for breakfast in Des Moines.

The convention was your first big test on this much larger stage, and you blew it. First, the security: turning downtown Cleveland into Guantanamo to contain and control a few perennial buskers with hand-lettered signs just looked desperate. I haven't seen that level of overcompensation since George W. Bush locked down Madison Square Garden in 2004, and that was with a half a million of us marching outside.

Then there was the lineup. When Republican and celebrity A-Listers snubbed you, you turned to the B, C, and D lists, and then threw them all together in an order that made no sense whatsoever. On night two, the last five groups and individuals on stage were playing to an empty arena. It was amateur night in BelieveMeLand, and it reflected badly on your self-vaunted skills as a pageant maker.

Your family did come through famously, but then you undercut them with your Bad Dad, il Duce impression of a speech, scaring the hell out of the nice people back home, and leaving your wife and children to sit on their hands flinching like abuse survivors. And you ceded the new grounds of patriotism, morality, and defense to the Dems in Philadelphia.

And here's a little tip for you, Scooter: You may have thought it was cute to treat the press badly throughout the primaries and culminating at the convention, drawing on that reliable reservoir of contempt the public has for the Mainstream Media. But the media has only so much patience for this kind of opportunistic demonizing. Media has a memory. And now that Ailes has left the building, you're going to need all the press you can get.[10]

So I suggest you strap yourself in and strap one on, Little Donald. We're heading into some serious turbulence.

— "Make America Great Again" at the RNC. Cleveland, OH. 2016. Photo by Susan Meiselas, Magnum Photos.

DISPATCH 20:
A VIABLE THIRD HORSE?

...

NEW YORK, THURSDAY, AUGUST 4, 2016, 2 PM.

Last night, CNN's Anderson Cooper hosted the second Libertarian Town Hall in New York, with the party's candidates for president and vice president, Gary Johnson and William Weld. As the Trump/Pence campaign continues to hurtle toward dumpster fire status, these two Republican ex-governors, Johnson of New Mexico (1995–2003) and Weld of Massachusetts (1991–1999), may conceivably have a larger role to play in this election than was previously thought. Right before last night's CNN Town Hall, one poll had them at 12 percent (most had them at 9 or 10 percent), and they only need to be at 15 percent to be included in the presidential debates. CNN has Green Party candidate Jill Stein polling at 5 percent, and will host a Town Hall for her and her running mate, Ajamu Baraka, on August 17.

The performance of Johnson and Weld last night suggested that they might very well best Trump and Pence in their respective debates. It is less clear how they would fare against Clinton and Kaine. But as more and more conservative and moderate Republicans flee the Trumpster fire, looking for an alternative to apostasy with Hillary, Johnson and Weld may have an opening.

In the 1990s, Johnson and Weld were two of the most fiscally conservative governors, and both were also socially liberal, supporting LGBT rights and the legalization of pot. Against Trump's bleak the-house-is-burning rhetoric, Johnson and Weld said last night that America is in a relatively good place now, but the ferocious rancor between the two main parties is making it impossible for anyone to get anything done. They're offering an alternative to this governing gridlock.

Concerning the current campaign, they said Trump "has a screw loose," and Hillary is part of the "beholden" class of "pay-to-play" politics. When Anderson Cooper asked them about their political models, both Johnson and Weld named Thomas Jefferson, for his "restraint and modesty." At one point, Weld described himself and Johnson as "a couple of nineteenth-century Jeffersonian liberals." Weld also said he admired Hugo Black and William O. Douglas on the Supreme Court, but declined to name his favorites on the current court.

In response to a question from the audience, Johnson said he and Bernie Sanders are in "about 75 percent" agreement on the issues; so disaffected Bernie supporters are another possible source of Libertarian votes. If their candidacy really begins to catch on, they might even attract some Democratic voters who harbor real reservations about their current standard-bearers, but that is, at this point, a long shot.

Their biggest problem at this point is Duverger's Law, which says that third-party candidates cannot win within the current Electoral College setup. One scenario would have the Johnson-Weld ticket drawing enough support away from the two major party candidates to prevent either from reaching the required 270 electoral votes, throwing the election to the House of Representatives. If that vote goes beyond the first ballot, we could have our first Libertarian president and vice president.

It is unlikely, but the current climate favors the unlikely. Whatever else happens, Johnson and Weld should be included in the debates, something that hasn't happened with a third party since Ross Perot in 1992.

following pages
— DNC. Philadelphia, PA. 2016. Photo by
Susan Meiselas, Magnum Photos.

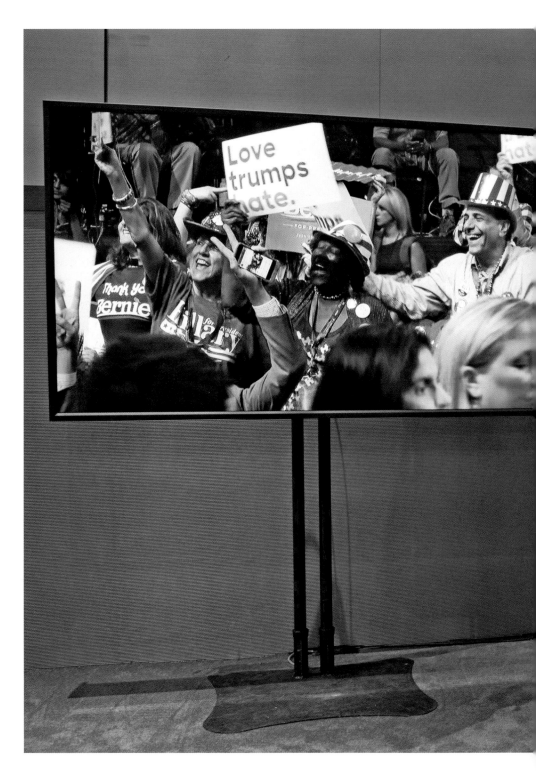

DISPATCH 21:
CLINT 'N TRUMP, TALKING TO THE EMPTY CHAIR

NEW YORK, SATURDAY, AUGUST 6, 2016, 2 PM.

In an interview just published in *Esquire* that was supposed to be about Clint Eastwood (whose movie about Sully Sullenberger starring Tom Hanks opens in September) and his son Scott (who plays an NSA official in Oliver Stone's new film about Edward Snowden, also out next month), writer Michael Hainey wisely steered the conversation toward the current presidential campaign, resulting in the biggest celebrity endorsement for Donald Trump yet.

It's been a bad couple of weeks for Trump, but this should pick him up. The one thing that hasn't been said about him is that he's boring, and for Clint, that is the gold standard. If Clint were to write a stump speech for the candidates today, what would he say?

"'Knock it off. Knock *everything* off.' All these people out there rattling around the streets and stuff, shit. They're boring everybody. Chesty Puller, a great Marine general, once said, 'You can run me, and you can starve me, and you can beat me, and you can kill me, but don't bore me.'"[11]

About Trump, he said, "He's onto something, because secretly everybody's getting tired of political correctness, kissing up. That's the kiss-ass generation we're in right now. We're really in a pussy generation [which is pretty much what Eastwood said about *my* generation forty years ago]. Everybody's walking on eggshells. We see people accusing people of being racist and all kinds of stuff. When I grew up, those things weren't called racist.... What Trump is onto is he's just saying what's on his mind. And sometimes it's not so good. And sometimes it's ... I mean, I can understand where he's coming from, but I don't always agree with it."

And Hillary? "What about her? I mean, it's a tough voice to listen to for four years. It could be a tough one. If she's just gonna follow what we've been doing, then I wouldn't be for her." Another Empty Chair.[12] "She's made a lot of dough out of being a politician. I gave up dough to be a politician. I'm sure that Ronald Reagan gave up dough to be a politician."

Hillary made it being a politician. Reagan made it being a bad actor and a worse president. Clint made it by feeding the American public's desire for law & order vigilantism with big guns, and then becoming a beloved icon of world cinema.

So, if the choice is between Clinton and Trump? "I'd have to go for Trump."

And with those six words, eighty-six-year-old actor and director Clint Eastwood solidified the angry old white guy vote for Donald Trump. Maybe it's the angry-old-white-guy-without-a-degree vote (Clint dropped out of L.A. City College to pursue his acting career). Call it the Gran Torino Vote. Talk to the chair, man, talk to the chair.

The reason that Trump is still in this thing, after running his general election campaign like a drunken teenager, is that enough people out there still see him as their protest candidate: a representative of the Old America, where, as Clint says here, you "get in there and get it done. Kick ass and take names. And this may be my dad talking, but don't spend what you don't have. That's why we're in the position we are in right now. That's why people are saying, 'Why should I work? I'll get something for nothing, maybe.'" "That's the pussy generation—nobody wants to work."

If you squint your eyes real hard, and look at Trump, you can glimpse your hero. Set aside for now the facts that Trump inherited his money and hasn't really made much of anything. He's made an *image*. And if that image resonates for enough people, the way Dirty Harry, or the Outlaw Josey Wales, or William Munny in *Unforgiven* did—the put-upon male just trying to muscle through and hold it all together while being attacked by stuffed shirts and "progress" and the Liberal Media and freeloaders and women with irritating voices—we could all still be in a lot of trouble.

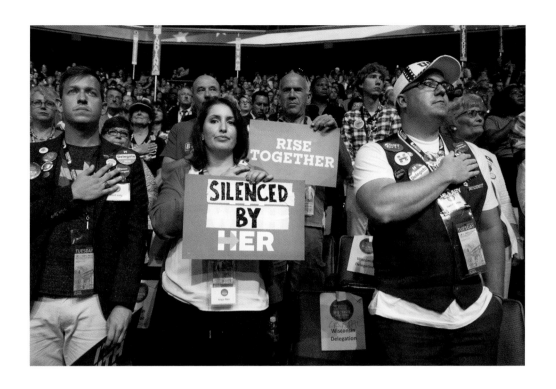

— DNC. Philadelphia, PA. 2016. Photo by
Susan Meiselas, Magnum Photos.

DISPATCH 22:
TRUMP 2.0, TURNING THE TABLES

NEW YORK, SUNDAY, AUGUST 21, 2016, 6 PM.

We're seventy-nine days from the finish line in the race for the U.S. presidency, and Donald Trump is trailing badly in the polls. Within the Reality-Based Community, it's beginning to look like a possible Clinton landslide. In Trump's beloved home city, he would lose 71 percent to 18 percent if the election were held today. It is becoming increasingly clear that he cannot win in a traditional campaign scenario. His only hope is to knock over the table, scatter the pieces, and emerge heroically victorious from out of the ensuing chaos. He must become part of the disruptive political economy that gave him his only constituency.

This is the rationale behind the recent shakeup in Trump's staffing. Paul Manafort has slipped back into the shadows of international intrigue. Stephen Bannon, the voice of Breitbart News, is the new CEO, pollster Kellyanne Conway is now Trump's campaign manager, and Roger Ailes is his unofficial consigliere and media handler. Rather than striking out into new territory, these three "hires" signal a return to the origins of the Trump campaign, in alt-right conspiracy and hate mongering, Frank Luntz-style linguistic twisting and subterfuge, and the image-conscious conventions of the new age of right-wing radio and TV.

It is a brilliant, if desperate, move. Kellyanne Conway came out of the gate hard, appearing on every mainstream media outlet that would have her (and they would all have her). She is a highly skilled spinner and disciplined messenger, a worthy disciple of Luntz. Bannon has held back for the moment, but his fingerprints are all over Trump's new teleprompter speeches. And Roger Ailes, the undisputed Master of the Dark Arts of mass media manipulation, is working so far behind the scenes that even his lawyers can't find him. But if anyone on earth can pull off a magical reversal of electoral fortunes for Donald Trump, Ailes is the one.

What makes a turnaround even remotely possible are the established voting patterns of Americans. Unlike other representative democracies, the U.S. has a shockingly low participation rate. The largest and most influential voting bloc in the U.S. has long been composed of those who choose not to vote. These are people who are so alienated from the political process that they freely abdicate

their first right of citizenship. These most separated citizens are the Holy Grail of electoral politics. And in the recent history of American politics, the Right has been much more successful in awakening this sleeping giant, by appealing to their sense of alienation, resentment, and paranoia.

This group is also demonstrably, historically fickle. In the last go-round, some of them succumbed to the hope and change message of Barack Obama, and many of those now feel they were duped. Perhaps it's time to turn the tables, they think. Or turn over the table.

DISPATCH 23:
WHY TRUMP CAN'T LOSE

NEW YORK, WEDNESDAY, AUGUST 24, 2016, 6 PM.

The current contest to choose the next president of the United States might very well be the first contest that Donald Trump has ever been involved in where someone other than himself will decide who wins. It is the first game he's ever played in which someone else is keeping score, and this has him terrified.

Think about it. He was born into wealth and privilege, where from birth he enjoyed the glorious protection from competition that those things bring. He never had to work for someone else. He never took orders in the military. His losses in business were initially covered by his father, and later by bankruptcy protections written into law by lawyers and lawmakers bought and paid for by big business interests. If the deal works, you keep the profits; if it doesn't, the public absorbs the losses. You can't lose. Risk is for the suckers who come to your casinos, and the poor slobs who work for you.

"Winning," in Trump's terms, means figuring out how not to play. If you can't make it as a real estate developer, create an image and a persona of success, and license *that*. Sell *that*. Sell the sweet smell of success. Every one of us, at some point in our lives, is susceptible to this sales pitch. We want to believe that we can get something for nothing, and that the only thing keeping us from the good life is our attitude, and other people.

If Michael Moore is right, Donald Trump never really wanted to be president, and he doesn't want it now. In a piece published on *Alternet*, Moore says he "[knows] for a fact" that Trump only ran in the primaries in order to boost his brand and wheedle a better contract from NBC for *The Apprentice* and *The Celebrity Apprentice*.[13] But then some Americans took his campaign seriously, and began to vigorously support him. He stumbled upon a whole new audience for his pitch. It felt good, at first. It felt like *winning*.

But then, problems arose. The principal problem, for Trump, is democracy. At least so far, the United States is still a semi-functioning representative democracy, wherein the president is chosen by voters in an election (or by a five-to-four vote

of a partisan Supreme Court). At this point, it looks as though Trump would lose in such an election, bigly. He cannot let that happen.

Moore's hypothesis is that Trump is currently sabotaging his own campaign as part of "his new strategy to get the hell out of a race he never intended to see through to its end anyway.... [H]e'll have to bow out or blame 'others' for forcing him out." The system, as Trump keeps telling us, is rigged.

If Moore is right, and Trump never wanted to be president, he is now actively looking for a way out, especially one that is advantageous to a new right-wing global media platform built by Trump, Bannon, and Ailes.

The only thing Trump cannot do is lose.

DISPATCH 24:
THE LAUER DEPTHS

NEW YORK, THURSDAY, SEPTEMBER 8, 2016.

With luck, money, and Matt Lauer, who needs a plan? The *Today Show* host should send Trump an invoice, after tossing him softballs for most of his half-hour interview last night, and failing to provide a modicum of fact-checking of the candidate's patently false statements. Or perhaps NBC News chairman Andy Lack has a bigger deal in the works, for a new *White House Apprentice* show on NBC.

NBC's event, sponsored by the Iraq and Afghanistan Veterans Association and held at the Intrepid Sea, Air, and Space Museum off the West Side Highway in Manhattan, with a clear view of the World Trade Center site, one week before the fifteenth anniversary of the attacks of 9/11, should have been a serious event. Instead, NBC treated it like a game show.

Trump won the coin toss and elected to go second. Matt Lauer opened round one by asking Hillary Clinton what she thought the most important quality was for a commander-in-chief. When she replied, "Steadiness. Steadiness and strength," Lauer said, "You're talking about judgment," and launched into a series of oft-repeated accusations about Clinton's use of a private email server as Secretary of State that took up half of Clinton's time. He paused only long enough to take the first question from the audience, from Lt. John Lester, a Republican. His question was, basically, "Why aren't you in prison?"

Granted, this was going to be a tough crowd for Clinton, no matter how it was handled. Polls show Trump is up about twenty points among veterans. But Clinton's credentials and experience in military matters are sterling, and to prevent her from talking about them in this forum was a premeditated crime.

Trump won the night because the form was all in his favor. He was more entertaining. You could see it in the faces and the body language of the veterans sitting around him. He said some outrageous things. He said that the people who gave him his mandated intelligence briefings made it clear (through their body language) that they were angry because Obama and his Secretaries of State Kerry and Clinton had not taken their advice. He said the Generals had been "reduced to

rubble" by Obama and that he would choose new Generals. And he said that he would "take the oil" in Iraq, because "to the victor go the spoils." The first two of these statements involve illegal and unconstitutional actions, and the third would constitute a war crime.

But Matt Lauer didn't respond to any of these outrageous statements.

This debacle on the Hudson is a dark harbinger of the presidential debates to come, beginning with the one September 26, to be moderated by *NBC Nightly News* anchorman Lester Holt. If the Lauer/Lack methodology continues in this forum, it will be almost impossible for Hillary Clinton to make her case to the public, and the rise of Trump in the most recent polls will continue.

Donald Trump's campaign, from the beginning, has been designed to obliterate the line between entertainment and politics. Obviously, this is a process that began long ago, and we are now in the terminal stages of it. We're still using the old language, but it's a new game. We still talk about "Trump supporters," but we mean Trump fans. Some older reporters who still remember "the News" and "broadcast journalism" natter on about their responsibility to the American people and the importance of a reasoned debate about political policies and issues. Trump himself continues to use this antiquated language at times, even as he ignores all of its precepts.

But this is truly a New Media World: one in which Trump's methods, and his politics, have the clear advantage.

Final celebration of the RNC. Cleveland, OH.
2016. Photo by Susan Meiselas, Magnum
Photos.

DISPATCH 25:
ROPE-A-DOPING THE MAINSTREAMING OF DEVIANCY

NEW YORK, TUESDAY, SEPTEMBER 27, 2016.

One of the many curious sights in Cleveland at the Republican Convention was boxing promoter Don King, who had apparently been snubbed by Trump as a speaker at the convention, working the room like a conquering hero. His salt-and-pepper *Eraserhead* fro caught the bright lights of the arena as he did interview after interview with adoring conservative media, draped in a massive denim jacket emblazoned on the back with a patriotic display, topped off with an American flag kerchief.

I thought of King in the run-up to the first presidential debate, as Paul Begala, among others, predicted that it would be "the most-watched event in human history." In October 1974, that designation belonged to the Rumble in the Jungle, in Kinshasa, Zaire, organized and promoted by the then-unknown King, that pitted undefeated heavyweight champion George Foreman against former champion Muhammad Ali. In that fight, Ali invented the rope-a-dope technique, baiting Foreman to pummel him with ineffectual blows as he leaned back against the ropes, until Foreman punched himself out, and Ali decked him in the eighth round.

The first presidential debate between Hillary Clinton and Donald Trump wasn't quite as impressive, in the end, but Clinton was able to bait Trump and goad him into a flurry of attacks that left him winded and gasping. She didn't knock him out, but most post-debate commentators gave her a clear victory on points. Neither candidate was working with new material, but Trump repeated old talking points and doubled down on positions he'd previously abandoned. He just couldn't help himself.

The weird thing is that Clinton might have won the debate, but still lost votes. Most people didn't think Trump could last through a ninety-minute debate, and he did show, as Maureen Dowd pointed out, that he can't take a punch. But he survived the encounter without visibly frothing at the mouth or weeping uncontrollably.

In the end, Trump might have benefited mightily among undecideds from a kind of presidential "mainstreaming of deviancy." My old friend Bob Dole used that term

in another context when he was competing for the Republican nomination for president in 1995 (on the way to being defeated by Bill Clinton), and trying to shore up his conservative bona fides. Dole's target then was the entertainment industry, including the music business, selling "'songs' about killing policemen and rejecting law," and Hollywood's dream factories, turning out "nightmares of depravity" that "revel in mindless violence and loveless sex." He singled out 2 Live Crew and Oliver Stone's movie *Natural Born Killers*, among others. "The mainstreaming of deviancy must come to an end," said Bob, "but it will only stop when the leaders of the entertainment industry recognize and shoulder their responsibility."[14]

What a difference twenty-one years of mainstreaming make. Today, Donald Trump has moved the language and methods of the entertainment industry over into the political realm, and it's mostly working. What Dole decried as a cultural coarsening is now seen as evidence of authenticity. Trump said some outrageous things last night, but they were normalized by the serious setting (and the constant, equalizing split screen) of a real presidential debate. Racist and xenophobic statements became part of mainstream political discourse, and will remain so for some time. Bob Dole's nightmares have come home.

DISPATCH 26:
HURRICANE
.....................................

NEW YORK, SATURDAY, OCTOBER 8, 2016, 1:42 AM.

Hurricane Matthew eclipsed Stormy Donald briefly earlier today, with lots of gray images seen through raindrop-covered lenses, until late in the afternoon, when the *Washington Post* released a three-minute video made by *Access Hollywood* in 2005, featuring Donald Trump bragging to professional celebrity lapdog Billy Bush about his remarkable power over women due to his stardom. When Billy Boy brought up a particular woman, Trump said he had "moved on her like a bitch," when she was married. He then mused that "When you're a star, you can do anything" to women, and they just take it.

It was remarkable to watch the entire news apparatus turn on a dime from the storm wreaking havoc in Haiti, Cuba, and Florida to the one doing the same to the presidential campaign of 2016. It felt like a violent change in the weather. Commentators and analysts went immediately to gale force, opining that this was the worst October Surprise any presidential campaign had ever faced, and predicting that this could finally be the end of Trump; that he would not be able to survive this politically.

Trump first released a statement about the video that read, "This was locker room banter, a private conversation that took place many years ago. Bill Clinton has said far worse to me on the golf course—not even close. I apologize if anyone was offended."[15]

I know locker room banter. And this was no locker room banter. This was the insecure posturing of an almost sixty-year-old rich predator who has always believed that his wealth and celebrity give him the right to degrade and abuse other people—especially women.

The timing of the *Access Hollywood* release couldn't have been worse for the Trump campaign, coming on a Friday night, two days before the second debate. The campaign went to DEFCON 2 very quickly, and released a video at 12:20 am EST on Saturday that was immediately characterized as "a hostage video." Squinting into the media glare, Trump said he wasn't really the person in the video anymore

(he'd changed), that this was "nothing more than a distraction," and that, anyway, Bill and Hillary Clinton are much worse. An hour before this "apology" was aired, Trump ghostwriter Tony Schwartz called it, predicting that Trump's statement would just make matters worse.

Access Hollywood says there are many, many more hours of video available from them, and Mark Burnett must be wondering if he is destined to become the Rose Mary Woods of our time.[16]

Even before the release of Trump's statement, it was being reported that many Republican lawmakers (including every one in Utah) were jumping ship, a meeting with Paul Ryan and others on Saturday in Wisconsin was cancelled, and Republican strategists around the country were openly contemplating how Trump might be convinced to withdraw from the race. Suddenly, Mike Pence's vice-presidential/presidential performance in Tuesday's debate looked more strategic and prescient than ever. If Trump is still looking for a way out of the race, he might just have found it.

DISPATCH 27:
THE NEW REAL
..

NEW YORK, SUNDAY, OCTOBER 9, 2016, 2:00 AM.

When Trump supporters view the *Access Hollywood* video, they see and hear something completely different from what anti-Trump people see and hear in it. But this is only the edge of the chasm. For Trump and his followers, words and images do not have a necessary relation to the Real. For them, words and images are endlessly malleable and therefore fundamentally untrustworthy. Their relation to the Real is always already *negotiable*.

When the video first appeared, Trump said, "These words don't reflect who I am." Melania said, "This does not represent the man that I know."[17] Neither they nor any of the Trump surrogates questioned the literal veracity of the video. They admit it shows Trump doing and saying those things. But that does not make it probative. It is just one more picture, no more consequential than any other. You have your images (and words), and we have ours.

Where does this fundamental challenge to representation itself come from? It comes from two very different responses to the communications environment that we've all come to inhabit over the past twenty years.

Trump fans hate "the media" because what's left of that entity still acts as if there is some underlying relation between symbolic systems and the Real. They compare claims and statements and images and try to determine their relative truth value. Trump supporters see this approach as inherently biased against them, and they are right.

They have their own channels of communication, distinct from what Sarah Palin used to call "The Lamestream Media." Three of the architects of this right-wing alt-media apparatus—Roger Ailes, Stephen K. Bannon, and Kellyanne Conway—are currently running the Trump campaign.

This campaign can be seen as the most recent twist in the culture of "disruptive innovation," and their ultimate target is the old model of critical questioning

and debate that has been the basis of representative democracy in America for 240 years.

Whether they win this election or not, their campaign to disrupt this model and replace it with a new authoritarian order of uncritical solipsistic certainty will continue for some time to come.

— Street outside the RNC. Cleveland, OH.
2016. Photo by Susan Meiselas,
Magnum Photos.

DISPATCH 28:
IT'S JUST WORDS, FOLKS. IT'S JUST WORDS.

NEW YORK, SUNDAY, OCTOBER 9, 2016.

I thought that Donald Trump lost the 2016 presidential race for good in the first fifteen minutes of the second debate. After staging a pre-debate press conference with three women who have accused Bill Clinton of sexual harassment in the past and then seating them in the front row of the gallery to glower at Hillary, marshaling his entire family to march into the debate as "spouses," and petulantly refusing to shake hands with his opponent, he seemed spatially disoriented onstage, even more nasally challenged than in the first debate, and generally cowed into submission.

The one thing Trump absolutely needed to do in this debate was to staunch the bleeding from the *Access Hollywood* video by stopping the defection of Republicans and other voters in swing states from his campaign. To do that, he needed to clear the air by coming out strongly and apologizing directly and convincingly. Instead, he again dismissed his speech on the tape as generic "locker room talk" ("It's one of those things … frankly, you hear these things, they're said … people say this"), and then stated that the things he said on the tape weren't nearly as bad as ISIS beheadings and torture. From that point on, anyone who was in any way "undecided" or "uncommitted" was no longer listening.

If they were, they would have heard Trump throw his running mate Mike Pence under the bus over Syria, threaten to throw his opponent into jail if he is elected, and accuse the moderators (especially Martha Raddatz) of being on Hillary's side. They also would have seen him smirk like an insecure teenager on the split screen, and then sneak up behind Hillary as she was speaking to the voters seated onstage and loom over her menacingly. In the last half of the debate, he finally found his rally voice, and repeated all his usual talking points fairly effectively. But if this had been a prizefight, Rudy Giuliani would have thrown in the towel after fifteen minutes, and Anderson Cooper would have thrown his body across Trump's to protect him from further unanswered blows.

Hillary Clinton managed to keep her cool despite Trump's adolescent antics, as did Martha Raddatz, and they both showed superhuman restraint when Trump began

to pontificate about his vast knowledge of military matters to these two longtime experts. Talk about locker room talk. His assertion that Assad and Putin are both "killing ISIS" was especially galling.

After the debate, CNN commentator Van Jones speculated that Hillary did herself a lot of good by *not* knocking Trump entirely out of the race in this debate. By holding him up, she kept him in the race for the time being, giving him time to bleed out. He's got thirty days to go.

DISPATCH 29:
THE BASE

...............................

NEW YORK, FRIDAY, OCTOBER 14, 2016.

At this point, twenty-five days from the election, it appears that Donald Trump has rebuffed all remaining attempts by surrogates and advisers to get him to do what is needed to broaden and extend his base to comprise a winning coalition. Instead, he has doubled down on the least attractive stances of his campaign and personality in order to isolate and harden his core constituency. The increasing danger for the country at large is what happens when this isolated and hardened core melts down.

This core or base (we remember that "al-Qaeda" means "The Base") could turn more violent at any time, as they continue to be publicly shamed and mocked, but especially when they conclude that the election of their supreme leader and political martyr has been stolen from them in The Big Fix.

I remember going home to Kansas for Christmas in 1994, to visit my family. My youngest sister's son had been living in Idaho with his estranged father, and had been radicalized into the militia movement there. When I spoke with him, he calmly espoused conspiratorial, anti-government, and xenophobic ideas, and at one point pronounced, "What happened in Ruby Ridge and Waco will not go unanswered. Something big is going to happen soon. You'll see, and you'll know." Four months later, on April 19, 1995 (the second anniversary of the siege of Waco), Timothy McVeigh and Terry Nichols parked a Ryder truck—rented in the town of my birth, Junction City, Kansas, and loaded with explosives in Herrington, a few miles away from where I grew up—in front of the Murrah Federal Building in Oklahoma City and blew it up, killing 168 people and injuring another 680.

In his speech yesterday in West Palm Beach, Florida, Trump said that the Clinton machine is at the center of this global conspiracy and the media organizations. He said the WikiLeaks documents released that morning prove that Clinton meets in secret with international banks to plot the destruction of U.S. sovereignty in order to enrich these global financial powers, her special interest friends, and her donors.

Dismissing the recent press reports about his serial sexual assaults on women, Trump said, "I take all of these slings and arrows, gladly, for you. I take them for our movement, so that we can have our country back.... This is our moment of reckoning as a society and as a civilization."[18]

This is not the language of a presidential candidate. This is the language of the leader of a violent movement to oppose a democratically elected government. I still believe that Trump stumbled into this role unwittingly, like the stooge he is, but at this point, the language and the rhetoric he is using are pushing him farther and farther to the right and his followers closer and closer to a violent backlash that he will have no control over.

Earlier tonight, the FBI arrested three men in Garden City, Kansas, for plotting to use car bombs to blow up an apartment building housing mostly Somali refugees. The three militia members had written an anti-Muslim and anti-immigrant manifesto and planned to carry out their deadly attack the day after the presidential election.

DISPATCH 30:
THE ELITES

.................................

NEW YORK, SATURDAY, OCTOBER 15, 2016.

It is the elites and their elite thinking that has screwed everything up for us. Elite thinking is dominated by political correctness. Their political correctness has caused them to put the welfare of Blacks, Hispanics, Gays, and others over our own needs. These groups are fine, but the elites act like these groups are better than us, more deserving. But Blacks, Hispanics, and Gays didn't build this country. We did.

The elites have let illegal immigrants get away with coming into our country and taking all the good things that were meant for us. They've let China and other countries take our jobs and then sell us back our own goods at inflated prices. They've given away everything our parents and grandparents worked for in unfair trade deals. Because they feel guilty about American power and dominance in the world, they've given up too much in trade.

Hillary Clinton represents the elites. She wants open borders. She wants to throw open the door and let everyone in, even Radical Islamic Terrorists who want to destroy us. She's weak. Elites are weak. They spend all their time thinking about how to take more from us and give it to politically correct groups. They have all kinds of excuses for why this is a good thing to do, but we just keep losing things.

When we look back, all we see is us losing things. We used to be on top, but now we're on the bottom. Maybe we should just give up and take welfare, like all the politically correct groups. But that's not our way. We're not like the Takers. We're Givers, like Donald Trump. He fought his way up and made something of himself, and now he's trying to give us hope, and a way forward.

He sees through the elites. He knows them. He could be with them if he wanted to be, but he chose to be with us. He understands us. He loves us. The elites hate him because of this. The elite media will do anything to bring him down. But we see through their attempts to demean and destroy him. They just can't stand that we love him. It drives them crazy.

When this is all over, we'll be on top again. Order will be restored. We'll take our country back. Trump will make everything work like it used to. He'll make everything okay again. We'll go back to the way it was before the elites took over. We'll be nice to the politically correct groups, but we'll be on top. This is the way it's supposed to be. It's only right.

DISPATCH 31:
THE APPRENTICE
··

NEW YORK, SATURDAY, OCTOBER 22, 2016.

Donald J. Trump is very good at one thing, and that is drawing attention to himself. He has spent his entire life honing this skill, and he must now be acknowledged as a master of it, in the New Century of the Self, when being famous for being famous is at its peak. Trump knows that the media cannot resist this tautology. This is the New Reality.

But the most consequential serendipity, for Trump, has been surviving into a time in American politics when a large portion of eligible voters, probably 35 to 40 percent, are so disgusted with the actions of politicians over the past decade, so frustrated by the system, and so angry about it all that they are willing to risk tearing it all down, rolling the dice, and starting over. Ever mindful of popular trends, Trump picked up on this growing frustration as an opening on the right years ago, and began reshaping himself into a spokesman for it. When Democrats were popular, he was a Democrat. Now, he's an apocalyptic Republican.

Up until now, perhaps until the third and final debate, the mass of the disaffected has been able to ignore the glaring character flaws of their messenger, including his naked bigotry. All that mattered was the core message of outrage, flung into the teeth of the hated Elites and their media apologists. Yes, he's a jerk, but he is our jerk. Good or bad, he's our Voice.

Tragically, the American Left has given them no viable alternative.

Trump's triumph has been to bring the bigoted language and rhetoric of social media, right-wing radio, and reality TV into a presidential campaign, for the first time. If that breach holds, political discourse is doomed in this country. I don't think it will hold.

The event last Wednesday night was not really a political debate, but a psychological pageant. Hillary Clinton held her own in this new arena. She gave as good as she got. Rather than hold back and let Trump destroy himself, as many advised, she went after him, and dominated him. The Hillary Clinton that confronted and bested Trump in Las Vegas on Wednesday night deserves our support.

Just as there are Americans who could never accept a Black man as president, there are many Americans, male and female, who will never accept a woman as president. But they are a minority, and they are going to lose this election decisively. What they will do in response to this crushing defeat is unknown, and worrisome.

In refusing to say that he will accept the results of the election, Trump has set himself outside of the democratic process.[19] The system may indeed be rigged, but it is not rigged in the way Trump is claiming it is. He is gaming the system the same way he always has, as a coward and a cad. But he's right about one thing: this election has indeed become a battle for the American character.

— RNC. Cleveland, OH. 2016. Photo by
Susan Meiselas, Magnum Photos.

DISPATCH 32:
ANGRY PEOPLE CLICK MORE

NEW YORK, WEDNESDAY, NOVEMBER 2, 2016.

As this Election Day, the most frightening hyperobject any of us has encountered in decades, looms, it is time to ask, How in the world did we get to this point? Has our communications environment become so appallingly polluted that we must take emergency measures to stop what we're doing and move in a different direction?

Adam Curtis (*The Century of the Self*, *The Power of Nightmares*, *Pandora's Box*, *Bitter Lake*, etc.) thinks so. His new film, *HyperNormalization*, which broke on BBC iPlayer on October 16, is about Brexit, immigration in Europe, suicide bombing, the war in Syria … and Donald Trump. In an interview with Jonathan Lethem for Lethem's profile of Curtis in the *New York Times Magazine* on October 27, titled "It All Connects: Adam Curtis and the Secret History of Everything," the filmmaker said that Trump had "realized that the version of reality that politics presented was no longer believable.… And in the face of that, you could play with reality." He described Trump as "a hate-bot. You go, 'I'm angry,' and he goes, 'I'm angry too!' And nothing changes. But the system likes it: Angry people click more."[20]

In Lethem's telling, Curtis sees Trump as a creature of what the Internet has become, or is becoming. "What will happen to the Internet in the future?" Curtis asks. "Will it become a bit like a John Carpenter movie? You go there, amidst the ruins, and it's weird, and you can be nasty—just have fun and be bad, like a child. From about '96 to about 2005 people built these lovely websites, they put up masses and masses of fantastic information. They've left them sitting there, but it's like a city that everyone's gone from. And what's come in instead is a weird world where you don't know what's real—just people shouting at each other. It's good fun, but it's not real."

This is the world Trump is reflecting and channeling. It is a virtual world, but it could have terrifying real-world consequences. If representative democracy is to survive in America, we are going to have to take back our communications. The unquestioning belief and certainty in the ultimate relativity and equivalence of all

information is destroying public discourse and making politics impossible. Trump is just the most visible symptom of this disease.

How we respond to this is going to be critical. At the end of Lethem's time with Curtis, the great filmmaker said about Trump's campaign: "It's the end of something—that's what I would think—and if it's the end of something, then it's about time we started inventing something new."

DISPATCH 33:
IT'S THE COMMUNICATIONS ENVIRONMENT, STUPID

NEW YORK, SUNDAY, NOVEMBER 6, 2016.

In a brief but substantive interview with Bill Maher broadcast on *Real Time* Friday night, President Obama reflected on the principal problem in our public life and discourse that has made it possible for Donald Trump to get this close to the American presidency.[21] "People have difficulty," he said, "just sorting out what's true and what's not. And if you don't have some common baseline of facts, ... it's very hard to figure out how we move democracy forward." The "Balkanization of the media," he said, where you have 800 channels and millions of discrete online sources, has led to a situation where everyone has their own version of the truth, and their own facts, and there is very little critical conversation across these boundaries. What we have is a vast collection of discrete sources with no real possibility of feedback, creating a nation of isolated monads, belligerent and lonely.

Of the American electorate, Obama asked, "How do we get enough information in front of them to be able to make good decisions? The problem is we have all these filters. Look, if I watched Fox News, I wouldn't vote for me either; because you've got this screen, this fun-house mirror through which people are receiving information. How to break through that is a big challenge."

Later that night, Bill Maher called what was happening now in the run-up to the election "a slow-moving right-wing coup," and warned that, "Once fascists get power, they don't give up. You've got President Trump for life." And Republican speechwriter David Frum (who's voting for Hillary) said that a small town in Macedonia was the source of over 100 pro-Trump websites, run for profit, and their Facebook posts get more traffic than any mainstream news source.

Trump has said that if he is elected, he will rule by Internet polling, where the loudest and least informed among us would prevail. In this dark vision, democracy would be replaced by a shadow of itself, a digital doppelgänger.

Democracy is about access and choice, but only when these are social, not measured individually, and not dispensed and controlled by huge corporations. The only cure for what ails democracy is more democracy.

On Tuesday, it is estimated that 50 million people will vote for an unqualified, narcissistic bigot, who, if elected, will drive the U.S. economy off a cliff and cause a global panic. If he is not elected, we are going to have to figure out how to reimagine and repair our communications environment to make critical engagement possible again, because the one thing the Trump campaign has made abundantly clear is that representative democracy cannot function without it.

DISPATCH 34:
FORTY-FOUR YEARS

...

ALLIGERVILLE, NEW YORK,
TUESDAY, NOVEMBER 8, 2016, 7 PM.

Tonight at dusk, we walked down the hill to the firehouse to vote. Our neighbors who live closest to the firehouse put huge Trump signs in their windows. Another neighbor stopped to talk. "It's almost over!" she exulted. As we walked back up the hill, the coyotes in the back field began to ululate in response to several firetruck sirens, and it made me think of the first time I voted in a presidential election, on Tuesday, November 7, 1972. I walked to the polls that day, too, in another rural firehouse, in central Kansas. I remember that the coyotes howled that night as well.

That night, I voted for George McGovern, who I'd worked for in Kansas. At the time, he was thought of by most voters as too radical and too much of an outsider. Republicans called him the "amnesty, abortion, and acid" candidate. An anti-war candidate, he declined to ever bring up in the campaign the fact that he was a decorated war hero.

McGovern lost to Richard Nixon that day in a historic landslide. He lost every state but one. He even lost in his own state of South Dakota. In Kansas, I think we lost every precinct. It was a complete blowout, nationwide. Nixon got 520 electoral votes to McGovern's 17. Nixon also received 60.7 percent of the popular vote, beating McGovern by 18 million votes.

We thought that the passage of the Twenty-Sixth Amendment to the Constitution the year before, to change the voting age from twenty-one to eighteen, a measure driven by the student activism of the late '60s (if you could be drafted and sent to Vietnam, you should be able to vote, we thought), would benefit McGovern. But in the end, young people went for Nixon.

The extent of McGovern's loss shocked me, but it made me even more determined to carry his convictions forward.

Less than one year after Nixon was re-elected, his vice president, Spiro Agnew, resigned in disgrace over a bribery scandal, and a year after that, Nixon himself resigned before he could be impeached over the Watergate scandal.

Whatever happens over the next few hours, this is how we choose our political leaders in this country, and it's better than all the other ways of doing it. It's worth fighting for. Election Day should be a national holiday, with feasting and celebrations, not a furtive thing, howling on the hill.

DISPATCH 35:
YEAR ZERO

....................................

NEW YORK, MONDAY, NOVEMBER 21, 2016, 3:15 PM.

Hello. I'm sorry, where were we? Howls of coyotes on the hill, signaling something dire. They usually howl like that after they've killed something, but that night they did it to drown out the emergency sirens in the valley. And it worked, for a bit. But then the sirens came back even louder, more of them, building, converging on the conflagration, till the din of emergency overwhelmed the ululation.

It's the way democracy works, sometimes. If you can get enough people worked up enough at the right time, and make enough noise to drown out all signal, you can take power, and kill something. And it happened that this year, it was enough. The center did not hold. Only a little over half of all eligible voters exercised their principal right in a representative democracy, and a little less than half of that group voted—in the right proportions in the right states, according to the rules—to shake things up.

The electorate that Tuesday in November was in a foul and unstable state, and they decided, just barely, to roll the dice and risk the fate of the free world on the brittle promises of a narcissistic huckster from Queens. Some of them had legitimate grievances, but all of them were angry enough to lash out blindly, consequences be damned. You'll listen to us now.

It was an almost unimaginably destructive act. It will wreak havoc on the environment, target minority groups and immigrants for harassment and worse, discourage our allies and embolden our enemies, and set back the goals of social justice in this country for decades. It will probably threaten American democracy itself before it's over, and upset the balance of power globally.

The day after the election, it definitely felt like something had died. Half of the population went into mourning, while the other half twittered and chattered its jubilation. We told you we were coming for you, but you didn't listen. The twenty-four-hour news channels turned on a dime, normalizing the results as if this is the kind of thing that happens every four years in America. Winners win and losers lose and life goes on.

But this is not like those other times. The darkest forces in American politics, which have seethed on the fringes of public life for 240 years, have suddenly grasped the reins of power. We have given power to an autocrat who will move rapidly to curtail rights and overturn all democratic institutions and legal safeguards against tyranny. And he will try to silence all opposition.

We all misread the signs. The Big Data wizards missed it entirely. Seasoned political hands were flummoxed. Our poisoned communications environment failed us. Mourning must happen, but not for long. Now there is work to be done.

PART II
THE NEW IMAGE

PROLOGUE IN THE THEATER (AFTER FAUST)

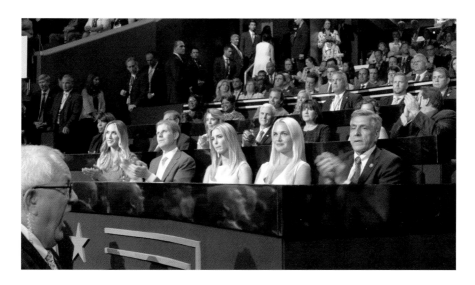

— The Trump box at the Republican National
Convention in Cleveland, Ohio. July 18, 2016.
Photo by David Levi Strauss.

Hello. Welcome to our world. It's yours too, now, in a way. You built it. We under-
stand that many of you thought it would turn out differently, and lead to some
democracy of affect. But you must have noticed the changes. You must have seen
them coming up on your screens. You must have noticed as the images began
to separate from their referents. You told yourselves it was a temporary spectral
shift, or a minor glitch in the iconosphere, but you must have seen it.

When we saw it, we knew that the image had been set free. It was no longer bound
by the old rules. The change began years ago, soon after Stewart Brand proclaimed
that "information wants to be free."[22] Then the image became information, and
once it was free of its old bond to the referent, to the signified, it became possible
to move images around, at will, and to make our own reality. Our Father taught us
how to move them around. Grandmother used to call it the *effet de réel*, in a fake
French accent, and laugh.

We are the disruption you have been preparing for all this time. We know who you are because He knows who you are, defined by what you want and fear. We were raised in the knowledge that we would eventually and inevitably control the future by simply reflecting your own desires and fears back to you. We were trained in these secrets of the black mirror, trained to rule. We always knew the time would eventually come.

We know that many of you were surprised when it happened, but you shouldn't have been. When the Social died, it was replaced by Social Media, and that was made for Our Father. When everything and everyone became connected, everything and everyone became controllable. When everyone turned the camera around on himself or herself, the circuit was closed. You freely gave up all of your information, including your image, and clamored to be told what to do.

Much about the change is still misunderstood. We are actually against politics, per se. In our world, there is no more class, no more alienation, and no more identification with the Other. Everyone wants to be like us. We are the revolution now, a revolution of the image, and soon everything will be revealed.

THE WORLD ON THE SCREENS

The images on the screens have become better and more beautiful over time, because I decide what comes up on my screens. I am in control of my own feed, and I choose from among an infinity of choices. I am free because information is free.

Because I am free, the old categories of right and left and right and wrong no longer apply to me. The old morality is dead. The old democracy has been disrupted. Our new democracy puts each user in control of his or her own destiny.

Once I give up my personal privacy, I can choose anything I want from the infinity of choices provided by other users. Everything that exists, exists on the screens. There is nothing outside of the screens.

The world on the screens is beautiful. All human problems can be solved, quickly and easily. We can eradicate world hunger, cure all disease, do away with poverty, and stop climate change. These are all technical problems. Believe me.

Politics is not the solution to our problem; politics is the problem. No one is in power. Mark and Jeff and Eric and Steve are not in power.[23] Donald is not in power. We are no longer citizens. We are greater than that. We are singular. We are singular. We are singular.

—February 20, 2017

following pages

— The Inauguration of Donald Trump as the
45th President of the United States of
America. Washington, DC. January 20, 2017.
Photo by Peter van Agtmael, Magnum Photos.

CO-ILLUSION

FREE TO BE YOU & ME

Now that we've had a Black president for eight years—and we don't think there's anything wrong with that—it's time we have a real American president, who we all know is American. That's only right, right?

Some of us actually voted for the Black president in the beginning, because we thought he'd bring Change. We gave him a chance. And now we've voted for a different kind of Change.

I am the least racist person you are ever going to meet, right? But there needs to be some balance here, some accommodation. Once you go Black, you can definitely go back, and that's what we're doing.

Some of my best friends used to be Black, until the Political Correctness thing took over, and I could no longer say what I wanted to say around them, or really, anywhere.

It was awful—like being all bottled up all the time, unable to express ourselves. It felt like we were second-class citizens, like we were being persecuted.

Then Mr. Trump showed up, saying everything we wanted to say but couldn't anymore. It was like being freed from slavery, for us.

Can you understand that? His campaign, for us, was like emancipation. America is all about freedom, you know, and we were freed to be who we wanted to be, thanks to Mr. Trump.

That's all we want, really. Just to be free to be ourselves. You want that, too, don't you? Can't we all just get along, now?

—February 21, 2017

TRUMP TALKS

You all talk a lot about the way Trump talks. You all have a big problem with the way he talks. You think the way he talks is unbecoming to a president. But for us, the way he talks sounds just right. He's not talking down to us, but straight at us.

The Black president was a master of your kind of talk. He wasn't quite as bad as Al Gore, or Hillary Clinton (don't get us started about that), but he still talked like he was better than us—like he was trying to teach us something.

Trump might be rich, but he knows how to talk to people who aren't rich. He's got the common touch. His talk reaches out and touches us, and that's what we've been waiting for, to have someone reach out like that.

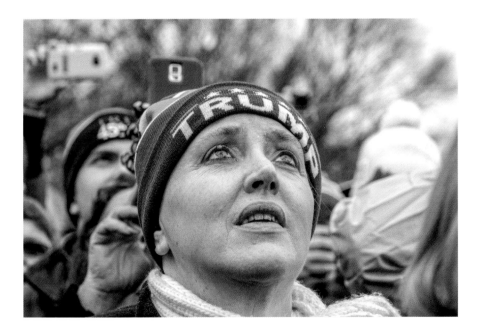

The Inauguration of Donald Trump as the
45th President of the United States.
Washington, DC. January 20, 2017. Photo by
Peter van Agtmael, Magnum Photos.

When Trump talks, you're always trying to catch him up on something, to catch him in a mistake. And then you do, but it doesn't make any difference. Because it's not about that. It's not a game. It's real communication, person to person.

You hate that, because if that caught on, your position in the world would be diminished. No one would need you to interpret everything, to decode and complicate everything, and to ask all your well-considered questions.

Your work, the tasks and skills that define you, would be obsolete. How do you think that would feel, to be obsolete? To have everything you know devalued and diminished and denigrated? What do you think you'd do then?

—March 18, 2017

PRIMING THE PUMP

If the day I just spent laughing it up with my good friends Sergey Lavrov and Sergey Kislyak and Henry Kissinger about our takeover of the White House doesn't make it clear to you, listen up.[24] I am not a mistake. I am not a fluke, or a bug in the system. I *am* the System.

I am more American than apple pie, because I bought the apples from Russia and had the pies made in Thailand.

You continue to cling to the fairytales you've been told from birth about "democracy" and "freedom" and America as the greatest country in the world, blah, blah, blah. But all that did was set you up for my "Make America Great Again" campaign play. I kept my slogan to four words, and most of my words to one or two syllables, because I know that's about all you can understand. Keeping you stupid has been the Business of America for a very long time, and business has been good.

In fact, it hasn't been about "America" for a long time. It's about money and power, and money and power don't care what you call where you're from. It's a market. What's changed in the last few decades is that it is now much more about who controls the images, because you believe in images more than anything else. If someone gives you the right image, they can get you to do almost anything.

I just fired the director of the FBI. Why did I fire him? Because he forgot who he was. He forgot that he was my employee. I love that look in their eyes when they suddenly remember who they are, right after I say, "You're fired." It's a beautiful thing. It's like killing someone, but not as messy. Bingo, you're gone, go away, disappear.

—May 10, 2017

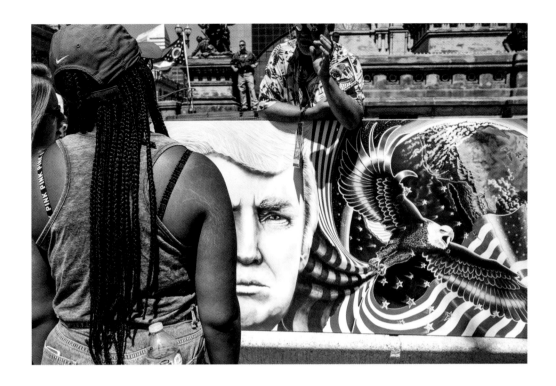

— Public square outside the RNC.
Cleveland, OH. 2016. Photo by
Peter van Agtmael, Magnum Photos.

PRIMING THE PUMP II

I have always seen myself as one of the best-looking guys, ever, I mean in history. Just to be honest with you, I was always the best-looking guy in the room, and the ladies all knew it—oh boy, did they know it. I could do anything, believe me.

Now that I'm President (can you believe it?), and I've won the presidency by a landslide the world has never seen before, the whole Machine for Making Images has turned toward me. It's now on me 24/7. It's unbelievable. They're all now busy making me look good. Making me look fantastic. I've never looked so good, and I'm now, what, sixty-nine years old? This is now their job, to make me look good.

Melania was there (I know, she's not here now, but fuck her) to reflect my beauty. I guess if you're talking about a guy, you're not supposed to call it "beauty," but I don't know what else to call it. I am a beautiful sonofabitch, you know? I mean, I'm like the fucking sun.

I've always known where the cameras are, always. I don't have to look for them. I just instinctively know where they are. Have you ever wondered why there aren't more incriminating pictures of me? I mean, there are some, and it's cost us a lot of money, but … the fact is, I always know when there is a camera eye on me. It's like a fifth sense. Fake News tried to make a big deal about the photos I had made of me and the two Sergeys after I fired Comey, like I didn't know I was being photographed. Please. And then I added Henry K in there, like a maraschino cherry on the shit pile. What do you think of this, you losers?

My enemies in the Media are always trying to make me look bad, but it never works, because I'm so beautiful. They're always talking about the "Trump brand." This is the Trump brand! It's me! Take a good look! Take a good, long look. Because this is now the face of the United States of America, whether you like it or not. And you should get used to it, because it's going to be the face of America for a very long time to come.

—May 12, 2017

A BLUNT INSTRUMENT FOR US

The People are great, but they are there to be manipulated by us. I mean, they have lives; they don't have much time to think. The Elites on the Left think the People spend all their time thinking about liberty and justice and minorities, but mostly they only have time to think about how to pay the bills, and why that's so hard to do, since they're working all the time. If you can connect with them on that, and really commiserate, everything else becomes possible.

The Blunt Instrument did that, big league.[25] He was born a millionaire, and now he might be a billionaire, but he thinks like someone on the bottom of the heap. He always thinks he's getting a raw deal. He always thinks somebody's trying to screw him, on everything, and that they're lying about everything. It's very charming. Especially to the people on the bottom, because it looks like a way out for them, or at least a way to strike back. It looks like the Blunt Instrument has a lot of Fuck You Money. It looks like a way for them to say Fuck You to everyone who's not on the bottom, and who has looked down on them all their lives. It's a tremendous reversal of fortunes; a real revolution, in emotional terms.

The Elites hate him because he doesn't buy their shit. He's got everything they say he should have—money, fame, a hot wife—but it's never been enough for them. They think he's vulgar. They think he's stupid. They think he's base. But now he's got a Base, and that Base just helped make him the most powerful man in the world. It's a Base to rival the Base (al-Qaeda) and ISIS.

Which is why I got into this. To me, this is all prologue. I have my eyes on the End, and the End is a lot closer than you all think. I'm not talking about your penny ante political games or your whining about a Constitutional Crisis. I'm talking about the ultimate conflict between Judeo-Christian Civilization and Radical Islam. The Pope doesn't get it, but all the people around him in the Vatican do. The previous heads of the CIA and FBI might not get it, but many of the people who work for them do. I don't know whether the Blunt Instrument really gets it, either, but it doesn't matter, because we do. And none of that will matter when the fighting starts. Then, only the Torchbearer will matter.

REUSE THIS CONTENT

Don't think of me as one of the wealthiest people in the world, or as the CEO of one of the largest and most powerful corporations in the world that owns most of your data, and knows more about you than your mother ever will. Think of me as a friend, trying to help. Look, it should be clear by now, even to those of you who weren't smart enough as a teenager to build a company that now earns $8.8 billion in one quarter and has 1.86 billion customers, that the whole "government" thing is not working. The world is too important a place (Elon!) to leave its governance to whatever old-timer can convince enough people to vote for them in a democratic election. If we're going to build a global community that works for all of us—that prevents harm, helps during crises, and rebuilds afterward—it's going to have to be run by someone who knows how to control masses of people—who knows, for instance, how to get masses of people to freely give up their personal privacy to a totally unaccountable corporation and then to pay for the privilege.

A cake at the Presidential Inaugural Salute to Our Armed Services Ball at the National Building Museum after the inauguration of Donald Trump as the 45th president of the United States of America. Washington, DC. January 20, 2017. Photo by Peter van Agtmael, Magnum Photos.

In the magic of money- and change-making, Trump is Old News compared to me. Just look at the numbers. He has good attitudes about some things, but he's still old. Old People—sorry, I mean older people, I'm trying to change that—have experience, but unfortunately their experience is mostly obsolete, because it's from analog time. It's not their fault, exactly: the world has just passed them by. But they shouldn't worry, because we're going to include them in the New World we're building. We actually like having them around, for "diversity" and color. And they can use the same infrastructure as we do, if they can figure out how to use it. They'll need to change some of their attitudes, of course. We can do without all that self-defeating talk about the "surveillance state," and "personal privacy," and "critical thinking." But they're welcome to participate, and communicate with the rest of us through Facebook, as we make further leaps from tribes to cities to nations to a global community built around our platform. It's going to be so good.

POLITICS PORN IN THE MORNING

Dear Joe and Mika,

Kellyanne here. You both must have to take a shower after every *Morning Joe* show, after spewing all your lies and self-righteous fake patriotic gush.[26] The fact that we all know you're taking that shower together doesn't improve the optics, for me. Mika, you're fat, and Joe, you look like a nearsighted windswept squirrel.

But let's get back to me. I know more about how politics actually works than the two of you ever will. I just got a nearly comatose, utterly incompetent jerk elected as the forty-fifth president of the United States. What have you done with your miserable little lives? Nobody gave us a snowball's chance to win. Not even the candidate! And now you all have to accept it and it's making you sick.

You must know how much I hate all of you Lamestream Media experts with your high and mighty "values." You're all just wannabes. If you could actually take power rather than just sit on your asses and comment on it, you'd do it. But you can't because you don't know how it works. I know how it works. I learned from the best: Frank Luntz. Frank knows more about message creation and image management than anyone else in the world.

My "alternative facts" coinage was an homage to Frank, who created the classics "death tax" and "climate change." We call ourselves "pollsters" just to confuse you, as if we are measuring public opinion rather than shaping it.

Frank and I know the secrets of how to control masses of people. We know the magic of symbols. You just follow what we do, like obedient dogs. I turned this country upside down and backwards. I brought out all the old suppressed anger and resentment and weaponized it. I overturned decades of liberal rule. And I did it with a diseased cretin for a client. I should be celebrated for this, not demeaned by lackeys like you.

When I let my hair down a little backstage, I thought I was dealing with honorable people, but you turned on me when I was down. You can be sure I won't stay down for long. And I never forget a slight. That's one thing the cretin and I have in common.

—May 15, 2017

following pages
— The Women's March on Washington, the day after
the inauguration of Donald Trump as president of the
United States. Washington, DC. January 21, 2017.
Photo by Peter van Agtmael, Magnum Photos.

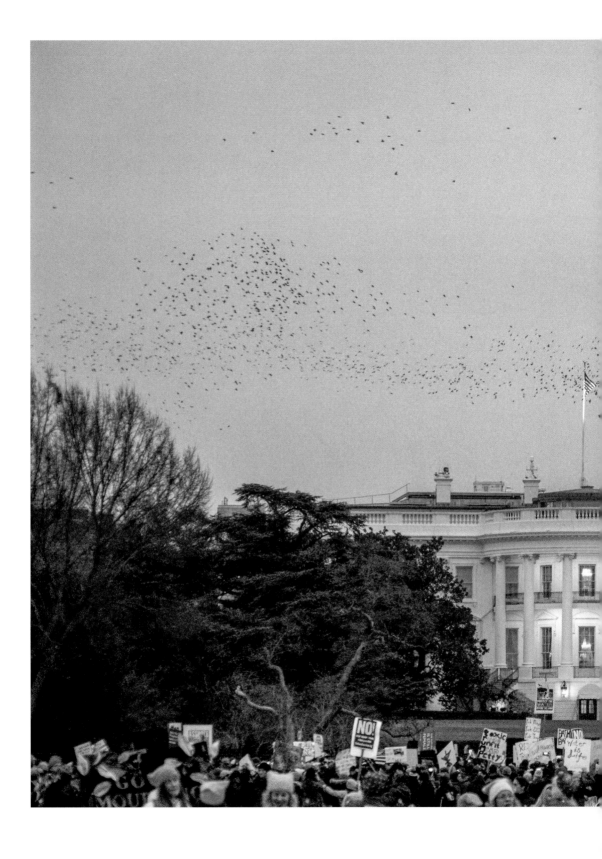

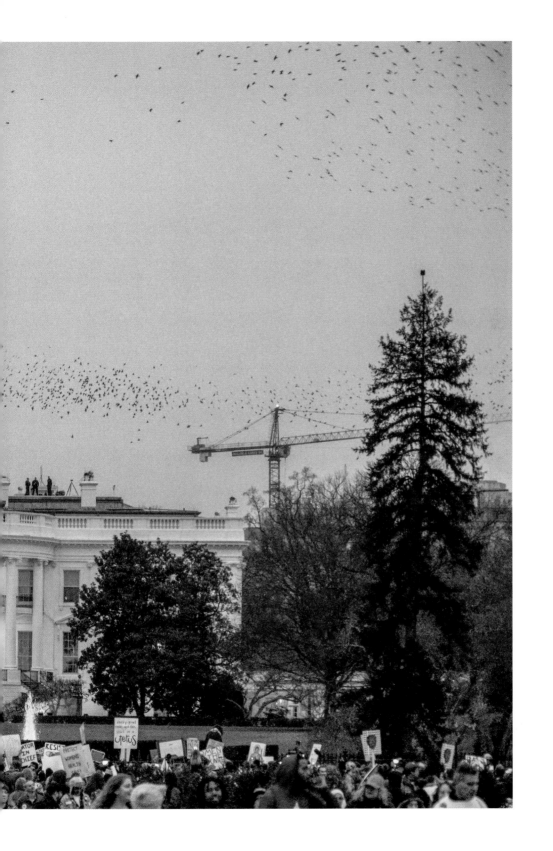

ERGO ERDOGAN

What happened outside the Turkish ambassador's residence in Washington this week was my kind of "brawl."[27] That's what the stupid Fake News kept calling it, after my friend Recep sent his security guys in to beat down the probably hired protesters, and then watched happily as they kicked and punched defenseless civilians senseless.

This is what I encouraged at all of my rallies. "Beat the hell out of 'em," I said. If these hired peaceniks come in, I say knock them down on the ground from behind or with sucker punches, and then kick and stomp their faces and heads till they break. Gang up on them. This works even better when you have highly trained security guys, which I've always had plenty of. If you've been paying attention, you've probably noticed that I am a physical coward. When a fight breaks out, I duck and run for cover, and look for my security guys. But I love to *watch* a fight.

A "brawl" means there's some back and forth, like it's a contest. You don't want that. That's for losers. Erdogan's guys waded into this peaceful protest and hurt people, fast, in ways that are going to take a long time to heal. That's the right way to do it.

If I want to see a contest, I'll buy a football team. This is why I always loved my man Mike Tyson. His fights, at least in the beginning, were never "contests." They were beatdowns. They were punishments. He went in and *injured* people, right away. If it's a "contest," that means you could lose, which means you're a loser.

I learned a lot in the casino business, and the biggest thing I learned was that if you think you're going to play a game and win, you're a loser. You win by running the game. You win by being the House, and the House never loses. Unless it's the House run by that loser Paul Ryan!

I was born rich, so I've always been able to buy muscle. And believe me, bought muscle is much better than your own muscle. It hurts to get hit. It's much better to pay other people to hit and get hit for you. That's why I like this guy Erdogan: because he understands this in a deep way. And he enjoys it. I think he and Putin and I are going to get along just fine.

—May 19, 2017

FREE PEOPLE

"Hackers are free people, just like artists who wake up in the morning in a good mood and start painting."[28] I don't know what they do if they wake up in a bad mood. I guess they just go back to sleep. These hackers are completely uncontrollable—they do whatever they want, no matter how much we pay them. Or threaten them. These free spirits might decide one day to send out a hundred or so messages comparing voting for Hillary Clinton to voting against Jesus. Or they might call Donald Trump an orangutan with a big butt. It's just whatever they wake up thinking. I think they get these things from dreams.

The Internet is just one big canvas for the artist in all of us. If we wake up and think, "Today I'd like to go after queers," or "Today I'd like to make it harder for people to get their blood pressure medication," then, by god, we can do it. Just like Stewart Brand and Steve Jobs intended. If you don't like it, maybe it's because you don't like freedom.

Finally, we have a U.S. president who understands the Internet and social media. Trump recognizes that this is the future. You can go along with it and use it, or you can get crushed. All of those who insist on clinging to the old ideas, about truth and justice and blah, blah, blah are in the way. We in the KGB saw all of this coming a long time ago. This is not a new Cold War. This is the new Info War, and it's hot.

The U.S. mainstream media ("Are these the guys who were giving you trouble?") are living in the past, with their fact-checking and fact-based reporting. All of that moves too slow. Trump has realized that 140 characters a day are worth months of "reporting." No one has time to go over all that. And it's boring. People want to see someone breaking things. They want someone to take charge.

What Trump and I really want is a world of artists, who wake up in the morning in a good mood and start painting. He and I will take care of the rest of it.

—June 1, 2017

following pages

— Police form a line to prevent protesters from deviating from Broad Street during the DNC. Philadelphia, PA. 2016. Photo by Peter van Agtmael, Magnum Photos.

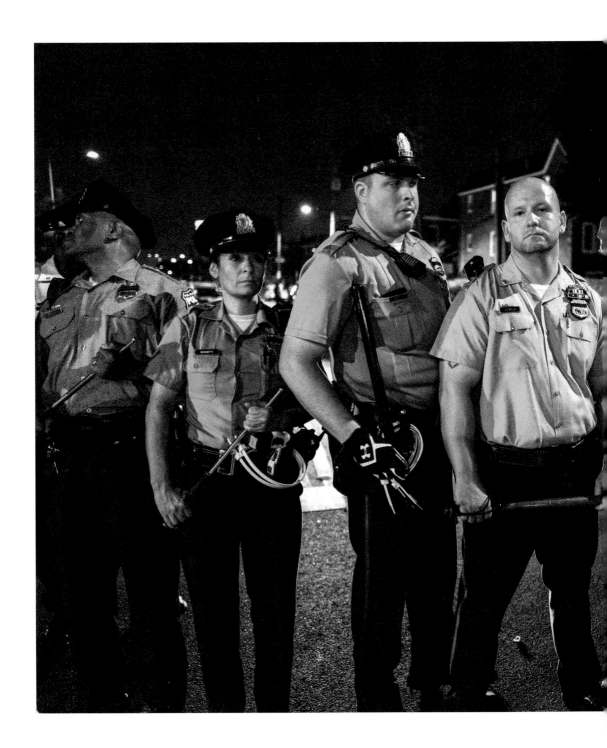

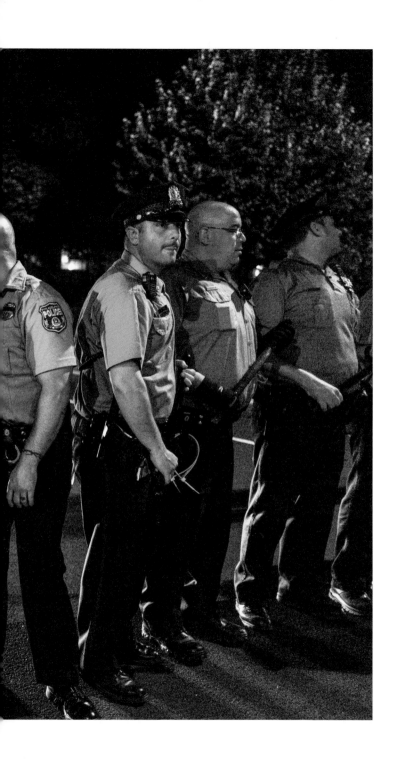

HANDS ON MY WEAPONS

Now I'm free. Now I've got my hands back on my weapons. My weapons are words and images and the media in which they operate. That's what this whole thing was about, for me. To build a media platform, a platform for communication, bigger and more powerful than the world has ever known. The mainstream media is no match for us, because they're still using the old Operating System, and it's obsolete.[29]

You can make fun of meme culture all you want, but they saw it coming. And I saw the future in those pathetic gamer boys, because I saw into the unconscious seething just under the surface of the Internet. Assange saw it, too, but from the other side, politically, at that time: "The world is not sliding, but galloping into a new transnational dystopia. This development has not been properly recognized outside of national security circles. It has been hidden by secrecy, complexity, and scale. The Internet, our greatest tool of emancipation, has been transformed into the most dangerous facilitator of totalitarianism we have ever seen. The Internet is a threat to human civilization."[30] But now he's on our side, or very near it.

Evola was on our side, too. Originally, he called it "magical idealism," after Novalis. He started with Rimbaud and Nietzsche. Eventually, he translated D. T. Suzuki and Durkheim, Bachofen and Meyrink, and the master, Guénon. They all came out of Guénon: Breton, Rolland, René Daumal, André Gide, Eliade, Huston Smith, Jacob Needleman, Titus Burckhardt, Seyyed Hossein Nasr, Kathleen Raine, T. S. Eliot, Henri Corbin.... But now the history of religions has come down to one big conflict, between the Judeo-Christian world and the Islamic one. Guénon's Sufism would have made him hate Islamic fundamentalism as much as I do.

Fame has always been about what is said. In the beginning, it was what the gods said, but later it became that which people say or tell. I got Trump to use the locution "people say" or "some people say" as a cover for the most outrageous and nefarious lies. Fame trumps everything, today. Perhaps even fate.

—August 18, 2017

FAME AND FREEDOM

His *virtue* is that he has no virtue. He won't say one thing and do another, because nothing he says matters, and all his actions are obvious and predictable. He won't disappoint us like you always have, raising our hopes up only to be dashed again. He can't disappoint us because our expectations are so low.

When you go high, he goes lower and lower.[31] We know those lower depths, where your hopes and dreams have been stomped on for so long, you form callouses on your soul. You hear yourself saying things you never thought you would. You think we are calloused in our language and images and our relations with other people, and you're right. If we didn't have callouses, we'd be in pain all the time. If you don't build enough callouses, you end up strung out on Oxy.

— The inauguration of Donald Trump as the
45th president of the United States of
America. Washington, DC. January 20, 2017.
Photo by Peter van Agtmael, Magnum Photos.

He knows how to talk to us, which is weird because he's a rich New Yorker. But he understands where we're coming from. He speaks for us. He's our Messenger.

You hate him because you thought he was one of you. You thought you could control him. But now he's ours, and you can't do anything to stop it.

He never exceeds expectations—he embodies them. What you see is what you see. It's such a relief after all your "I have a dream" crap. You more complicated, entitled sorts don't get it because you're always looking for some underlying meaning or motive. But his motives are always absolutely transparent. He wants what we all want: to be rich and famous. Don't pretend you don't want that, too. You just don't want to be so obvious about it, and his being obvious about it galls you—because he's obvious about it, and he still gets it.

He is now the most famous person in the world. And there's not a damn thing you can do about that. In fact, everything you do every day, responding to everything he says and does and trying to find "meaning" in it, only further ensures his undying fame.

He has reached that level of fame where none of the rules apply anymore. He can do or say anything he wants, and it doesn't matter. He's like one of those Greek gods now. He's immortal.

—August 22, 2017

F IS FOR FAKE

Last week I invented the word "fake."[32] I don't know why nobody had thought of it before. It's the perfect word, the best word I've come up with. When the elites make something up about me, it's fake, like Fake News. It means they just make it up. It's the make-and-fake. It's a full-time job for some of these losers.

When I say, "believe me," that means it's true. When they say something's true, it means it fits in with their skewed view of me. They use it to try to stop me. You can believe me or you can believe CNN, but you can't believe both. You have to make a choice. That's what you did in the election: you chose me. That means CNN and the *New York Times* are finished. It's over. They're failing, and I'm winning now. I've already won.

This whole "truth" thing has always been used against me, all my life, and it's never stopped me. I have better ratings. I sell more copies. People like me better. Every once in a while, I'll say something true just to show that it doesn't matter. I mean, it doesn't hurt me. It can be true or not true, who the fuck cares? I'm so much bigger than this.

Do you know how long they've been trying to stop me, with this truth shit? Do you know how many times I've beaten them, over and over? You'd think maybe I could get a little respect from them, a little break. But no, it's fact-check this and evidence that, and it's a Constitutional Crisis, and a Special Prosecutor with special subpoena powers. . . . It never ends.

Now they think they can get to me through my kids. And I love my kids, but they don't have what I have. I have the secret to the whole deal. The Art of the Deal. I learned it from a Japanese Whale. Now, I'm bulletproof. Nobody can get to me.

What's true is that I am the most famous person on earth. In fact, I am the most famous person the world has ever seen. Think about it. And right now, I'm the most powerful person on earth. I live in the White House, and I can do whatever I want. That's the truth.

—October 9, 2017

— A young Marine Cadet at a Marco Rubio rally.
Donald Trump ultimately won the New Hampshire
Republican primary and Bernie Sanders won
the Democratic. Londonderry, NH. 2016. Photo by
Peter van Agtmael, Magnum Photos.

MY GENERALS

I love my Generals. If I have a four-star General standing next to me, what else do I need? They don't even need to say anything. It's like holding a gun in a business meeting. People treat you differently. Gotta have your Generals. Putin understands this. Erdogan understands. You know who doesn't understand? Democrats. Obama tried to make the military feel guilty about everything. I'm actually surprised they didn't frag the.... Sorry, what was the question?

I know you have to stand up and ask your questions, as if it still matters. You don't get that I've moved past that. I have the power now, not you. You've got nothing. Nothing. Katy, Peter, Matt, Angela. How much did you make last year?

You want to ask about my military service. I went to military school. I learned how that whole thing worked. I got it, so I didn't need to continue. I'm intelligent. I'm a smart person. I looked at it, and I said to myself, "Hmm. Do I want to continue, go to officer's training, work my way up through the ranks, etc., etc., maybe get shot at? Or do I want to strike out on my own, make my own way, and get to the top?"

Did it work? Well, let me ask you, Do you think it worked? I now hire the Generals. They work for me. They do what I say. And I love 'em for it. I don't need to know everything about what the military is doing. You know, in the beginning, they wanted me to sit still for these extensive briefings, and I said no. I'm smart. I don't need to know everything. Let the Generals do what they want to do. That's why they like me. The troops love me, and I love them. I love the poor and the poorly educated.[33] I really do.

Why do you think they turned against everything you believe in, everything you stand for? Because it wasn't getting them anything. It wasn't doing anything for them. The more you talked about freedom and justice for all and sacrificing for your country, the more they got screwed. You got freedom, illegal immigrants got justice, and the poor and poorly educated did all the sacrificing. You say you thank them for their service, but you don't do anything for them. You think they're stupid to sacrifice like that. You think they're suckers. You think anybody that goes into the military does it because they can't do anything else.

I know what it's like to be looked down on. I know what it's like to be treated like some lesser form of life because of my views. Like I don't use the right language, and I don't do the right things.

Well, now we're in power. We're calling the shots. And you better get out of the way if you don't wanna get hit.

—November 4, 2017

IT'S NOT ENOUGH

It's not enough. It's never enough. It's never been enough. Some people, from out-side of me, say that I've got it all now. But they don't understand. I've had it all for a long time. It took me a while, but I figured out how things work, in the trenches of New York real estate. This is the crookedest and toughest arena in the world, and I figured out how to survive and win.

I've known that I should be the Leader of the Free World since I was twelve, and later on, I couldn't understand why they didn't just make me Leader. It was only a matter of time. I watched things change to make it inevitable. It finally happened, but it's still not enough. I have unlimited power, and it's not enough.

As usual, the liberal Fake News and the phony and dishonest justice department are against me and are trying to destroy me. That's always been the case. But now they can't get me. I'm the head of the whole thing. I'm the Top Cop, the "chief law enforcement officer" of the country. These losers are now talking about me "obstructing justice." How could I obstruct justice? I am justice. I am the law.

And there's no "collusion." No collusion at all. Putin and I don't need to collude. We're on the same side! We're the same kind of person. We take what we want, and make deals to further our interests. Collusion is for losers.

I've actually read the Constitution, and it's a very nice set of guidelines, but it doesn't apply to me. The truth is, I've always been above the law. OK, "above the law" sounds bad: I've always been *aside* from the law. It doesn't apply to me. My father taught me early on that what most people think of as "the law" is deter-mined by lawyers and politicians, and lawyers and politicians can be bought, just like anybody else.

Republican politicians rolled over much easier than I expected. I expected some resistance. But no, nothing. And the Democrats? Please. It was like taking candy from a stupid fucking baby.

The law belongs to those who can hire the best lawyers. Today all the best lawyers work for me. The FBI works for me, the CIA works for me, my Generals work for me. Everybody works for me. And since they work for me, I can fire them if I want to.

The losers said that if I fired Comey, it would be a big deal and it would hurt me. But look: nothing happened.

It may look bad right now, but believe me, I've seen worse. I've been up against the mob, and democracy is nothing compared with the mob.

—December 4, 2017

A polling station in Nashua, NH, on Primary Day. Donald Trump ultimately won the New Hampshire Republican primary and Bernie Sanders won the Democratic. Nashua, NH. 2016. Photo by Peter van Agtmael, Magnum Photos.

SPECIAL COUNSEL

Mueller is living in the past. He's acting like the Trump Revolution never happened. Like the "rule of law" is still in effect and that I am subject to it. He didn't get the memo, I guess. We changed everything. The American people elected me because they were sick and tired of the old way of doing things, including the elitist rule of law. And I've come in and wiped it out.

I've played the law for my entire life, and I've always won. You wouldn't believe the stuff I've gotten away with. And now I've gotten away with the big prize. I am the law.

My father and Roy Cohn taught me a long time ago that the "rule of law" that liberal elites worship is a joke.[34] The law has always been, from the very beginning, a cover for real estate deals. The Declaration of Independence? Please. This was the biggest land grab in history. I mean, these pieces of paper and the founding fathers and all that is a pretty story, I guess, but it's always been Fake News.

Roy Cohn was a genius. He figured it all out. He got inside the mechanism. He figured out how to pull the levers and he taught me how to do it. A lot of it has to do with the manipulation of images. Roy called them "phantasms." He said I was a Natural at this. He saw that I was a genius, too. I don't know how to talk about it all that well, but I know how to *do* it, better than anyone who's ever lived.

The elites are still busy trying to "clean things up" and "restore order" or some shit, as I continue to move ahead. While they're following the bouncing ball, I'm stacking the U.S. judiciary. Very soon, it will all be done. The Federalist Society (the Gold Standard) gave me all the names, so I didn't need to do all that research myself. They told me who to put in place and I'm doing it, one after another. And when I'm done, the "law" in the U.S. will be controlled by right-wing judges for the next half century or more.

So, ask me again if I'm afraid of what Boy Scout Bob Mueller and his troop are going to do. Please. Believe me.

—March 15, 2018

PORNSTACHE

As you know, Bannon wanted Bolton all along, for State or National Security, but I held the no-mouth-hair line.[35] Call me old-fashioned, but I really want males and females to shave everywhere but up top. I prefer a small, naked, expressive, somewhat pouty mouth on both males and females. All subterfuge in males should be concentrated on top, where the real art and architecture happens.

My Generals like to be bald, I know, but on everyone else, I hate baldness. To me, it's like giving up and giving in. Who decided I should lose my hair as I got older? Not me! I actually inherited this sense of resistance from my mother. She was a real fighter. Never give up, never give in!

At a certain point, Melania refused to shave everywhere, so I stopped servicing her at all, except for procreation purposes. I went elsewhere. That's never been a problem for me, believe me.

Politics has always been a lot like sex to me. I've never had any problems in either area. I've always been able to do whatever I want in both areas, because people really like me.

Have you seen the people at my rallies? It's like true love, expanded. I can do or say anything, and they'll still love me. You know why? Because I love them, too. I really do. It's very pure. Like a mouth without hair around it.

—March 23, 2018

TOOL FOR CONVIVIALITY**

I'm a tool. Facebook is a tool. We can't control how that tool is used. We're not into control. We're into sharing. We provide a service to share content. We're all form, and no content. If billions of people want to share their content with others, and share their data with us to pay for the service, so we can sell it to various vendors, they're doing that out of the goodness of their hearts or because they're fucking idiots. Either way, we're not liable.

We're just like the gun companies. We make a tool, and we can't control how some people choose to use that tool. Everyone is free. You can't wait for a tool without blood on it.[36]

Data breaches don't influence elections; people influence elections. Information just wants to be free. It's not about politics anymore—it's about engineering.

I'm just a software engineer who has become extremely successful. Early on, I saw a way to exploit the natural tendencies of people to want to be popular, at all costs. The truth is that only a few people can be popular in any given group. So, if you offer people the opportunity to *feel* popular by amassing imaginary "friends," in exchange for giving up their personal consumer data, most of them will jump at the chance. It's like a functional Narcissism Machine. In their terms, the cost is minimal. In our terms, the profits are enormous. Bingo: Big Data Capitalism.

Aleksandr Kogan and Cambridge Analytica and all the dark web data brokers out there have made it a little hard for us right now, but we'll get through this.[37]

—March 24, 2018

** In 1973, the great philosopher and political thinker Ivan Illich published *Tools for Conviviality*, in which he argued that helpful "convivial" tools can quickly turn into destructive ones: "A tool can grow out of man's control, first to become his master and finally to become his executioner. Tools can rule men sooner than they expect; the plow makes man the lord of the garden but also the refugee from the dust bowl." Illich ultimately saw technocracy as a step towards fascism. Ivan Illich, *Tools for Conviviality* (New York: Harper & Row Publishers, 1973), 84.

DAMASCUS

A picture of dying children is worth 100 missiles.

I knew Lying Obama was wrong about his "Red Line" before, but it didn't really hit me until Ivanka showed me photographs of children foaming at the mouth last year.[38] That did it for me, and I immediately ordered an airstrike. And people seemed to like it. The ratings were high, *high*! They like a president who acts rather than one who just talks, like Obama, that faker.

They also like it when a president repeats himself, so when I saw more photographs of children foaming at the mouth this month, I sat down with my Generals and we figured out how I could "bomb the hell out of them" without hitting any Russians or Iranians, and then I just pulled the trigger. Someone has to pull the trigger.

And if I see more photographs of children foaming at the mouth, I'll do it again. You can say whatever you want about how cold-hearted I am, and how I don't feel things, but pictures of children being gassed really get to me, I don't know why. I guess it makes me think of my own childhood, feeling angry all the time and unloved. Or it makes me think of the birth of Barron, in March 2006, and his baptism in Palm Beach soon after. That's when everything changed for me. Melania, my beautiful wife Melania, disgusted me after that. And Mike Cohen really had his work cut out for him after that, let me tell you![39]

But now I have another outlet for all that disgust and remorse. When the missiles started falling on Damascus, I felt a tremendous relief.

—April 23, 2018

ORGANIZED CRIME

I learned early on that, with organized crime, it is sometimes to your advantage to look and act disorganized. Show up in a bathrobe, etc. Do what no one is expecting you to do. Act like you don't know what's going on. I also learned that, aside from the family, it's always good to keep everyone else around you a little off-kilter and on edge. If you're in charge, everyone who works for you is temporary.

On second thought, that goes for the family, too.

My father and Roy Cohn taught me that this is a good strategy for ruling, for staying in control. Later, Mark Burnett helped me see that this also makes for great TV. Everyone's on edge, everyone's nervous, everyone's afraid. Perfect storyline.

You all say you don't like this, but everything you do shows me that you all live to *watch*. You can't take your eyes off me.

The old rule for tragedy was keep your hero in trouble. But things have changed now. The mood has changed at the millennium. Now people want a hero who is strong and makes his own rules, regardless of what the Fake News or the Government or the Pundits think, and one of the ways this stays clear is if everyone around Him is in trouble. Nobody knows what's going to happen next. It keeps an audience's attention.

This "Rule of Law" thing is Fake News. No one cares about that anymore. And that's convenient, since almost none of it applies to the President, anyway. The only people that can go after the President are The People, and they love me.

The secret is to keep people's attention focused. It doesn't really matter what it's focused on, just that you're determining what that is. It's about sleight of hand, conjuring, magic. Why do you think stage magicians work in casinos? And why do you think organized crime went into casinos? Get them to look over here while you're doing what you want to do over there. It's basic stuff, but I've always had a knack for it.

It's the same way with prostitution and porn. Stormy Daniels is actually one of the best in this. She conned me, and believe me, that's hard to do. So, I like her. But now she and her shyster lawyer have to go down, and I'm going to make it hurt, all the way down, for them and their families.

—April 23, 2018

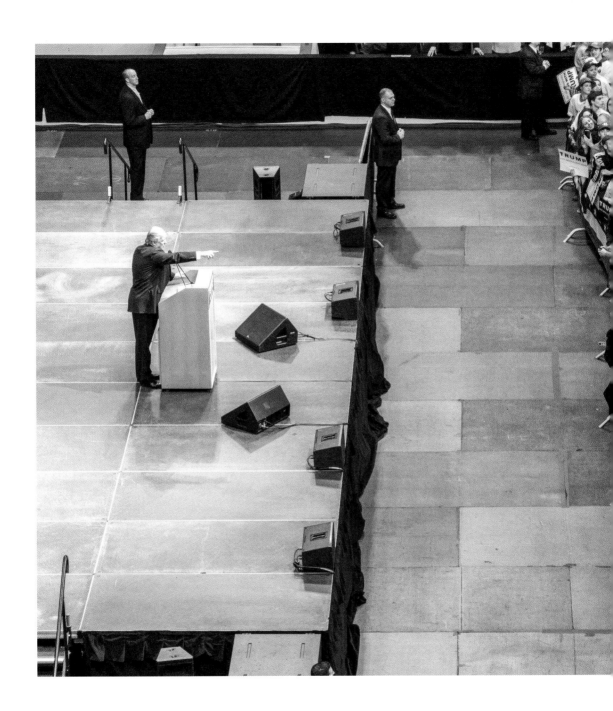

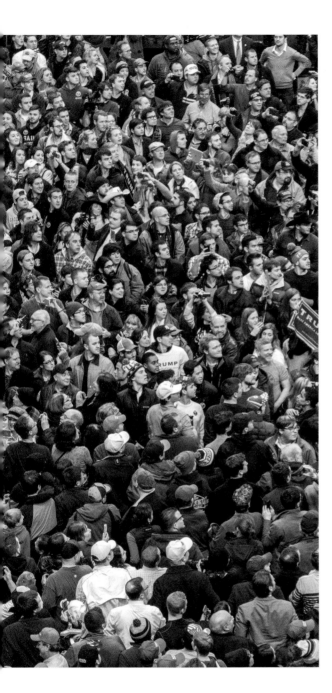

— Donald Trump addresses the crowd at a rally at Verizon Center on the eve of the New Hampshire primary. Donald Trump ultimately won the Republican primary and Bernie Sanders won the Democratic. Manchester, NH. 2016. Photo by Peter van Agtmael, Magnum Photos.

FOX AND FRIENDS

He may be the most successful con man in history atop the most powerful nation in history. He has prevailed in a way no other spinner of tales has prevailed.

Trump biographer Michael D'Antonio[40]

Look, I am the culmination of American history. I'm it! America is all about, and has always been all about, extraordinary individuals. And I am, believe me, the most extraordinary individual anybody has ever seen. This is what it's all about. Voters liked me because they said, "This is the greatest guy we've ever seen running for president." Not like any of the others. I mean, some of the others were good, but this is different. That's what Americans believe in: the power of a single individual to change things.

That's why this other thing that's being bandied about as the thing that could bring me down, the "rule of law," is not nearly as powerful. This is what the "justice" department would have you think, that this thing is more important than the choice of the people. But it's not, it's not!

Look, they elected me and now I'm choosing the judges. I'm choosing the people at the top, who interpret the laws! And we're going to replace all the people in Congress who disagree with us, so that will take care of the people that make the laws. And we already have the police and military and so on behind us, the people who enforce the laws. And now I've got Rudy Giuliani! So, what are they talking about with this "rule of law" shit?

So, I have some trouble with the FBI. Rudy is going to fix that. And the so-called Special Prosecutor is surrounded by Democrats, so that's not going to fly.

In the end, this "rule of law" thing is un-American. It's against the primacy of the individual in favor of the "collective good" or "community" or something. Where have you heard those terms before? As Roy Cohn used to say, "I don't want to know what the law is, I want to know who the judge is." It's always been about individuals. Ask Kanye.[41]

Roy Cohn told me that McCarthy bought anti-Communism like someone else would buy a car. I bought populism.

—April 28, 2018

MELANIE. MELANIE?

I know a lot of people are saying that Melanie did not go into the hospital for kidney problems, and now that she hasn't been seen by anyone for almost a month, people are saying she is hiding after attempting suicide. Can you believe this?[42]

Melanie is my supermodel wife. Before I met her, no one even knew her name. I pulled her out of total obscurity into the Big Time. Do you know what that means? She became Donald J. Trump's wife! Thousands of women, probably millions, would die to become my wife.

Look, when you throw in with a Big Dog, a Top Dog like me, it's not always going to be easy, pre-nup or no pre-nup. But I've given her so much. Like any woman, she always wants more—that's just how they're made. But, jeez, give me a break!

On top of everything else (as if she didn't have enough), I made her the First Lady, married to the greatest President America has ever had, in the history of the world. She's living in the fucking White House! Who doesn't want to live in the White House? Still, she complains.

I'm thinking of throwing her out on her ass. Other people can take care of Barron. He's getting to be old enough to take care of himself, anyway. I did. Let Melanie go back to the Old Country, and see how things are there.

—June 2, 2018

KULTURKAMPF

When I hear the word "culture," I reach for my dick. People talk about culture like it was a religion, like it was holy. But I figured out a long time ago that culture is just something you buy when you have enough money, and then have your wife take care of it.

America turned into a junk culture a long time ago, anyway. Reality TV caught the mood—watching flawed people do flawed things. Except me. I was always above it all in *The Apprentice*. I was above the junk, deciding who to fire.

Now, I've replaced culture. I'm the biggest and best show there is. No one else can compete with me. I'm like the best artist there's ever been. Could Picasso hold a crowd like this? Could that twink Andy Warhol? Fifteen minutes. Try seven decades!

I always wanted to be a writer, and now look at me. I have a bigger readership than Hemingway ever dreamed of! They wait around for it and then it goes everywhere. The big mistake before was to think you have to read to write. Why?

I don't have time to read. I'm too busy writing the world. And people are too busy reading me to read anything else. They can't wait to see how it will all end. Even I don't know that. But I know it'll be good.

—June 3, 2018

PARDON ME

Scooter Libby was kind of a fluke: a blast from the past. I'd actually never heard of him. Then Sly Stone gave me the Jack Johnson idea. That was a good one, for my Black people. But it was just a prelude. Dinesh D'Souza, Martha Stewart, Rod Blagojevich. I'm just getting warmed up.[43]

I'm like the Pope selling indulgences, forgiving sins. It feels good. I never thought about it like this, but the Pope was kind of going up against God. A gutsy move. God condemned sinners, and the Pope let them off. People talk about "The Rule of Law" and "Justice" like that, like they're holy writ, but it's really just all about who decides. Even that idiot Bush knew that: "I'm the Decider."[44]

Now I'm the Decider, and if I want to, I can just clear the decks. Reset the clocks.

—June 3, 2018

KIM & ME

I told you during the campaign that only I could fix this. If someone else could have fixed it, they would have, but they didn't because they couldn't because they were pussies. So I will.

I understand Kim. He's a tough guy. Killed his relatives in cold blood.[45] Like me, he was raised to be strong and to lead, and he's done pretty well, I must say. He's got the South, Japan, and China by the balls, and all he has to do is squeeze whenever they move against him. I respect that.

The haters in Fake News are living in the old world. Kim and Putin and I are the new world. They're all saying that I lost something just by meeting with Kim, but they don't get it. I've got the whole world watching. Best ratings in history. That's a win. Those pictures will live forever.

Justin Trudeau stabbed me in the back at the G7 by trying to upstage me in his powder blue suit, and he will pay for that. There is only room for one top dog and that's America and America is me. I like America and America likes me. America's biggest gift to the world is the Spectacle: reality TV, movies, celebrities. Spectacle draws attention, but not scrutiny. This is why we're winning, not some bullshit "rule of law."

—June 5, 2018

86.9%

Right now, my approval rating among registered Republicans is higher than any President ever, other than George W. Bush right after 9/11. 9/11! I don't need Democrats, I don't need the Mainstream Press, I don't need the liberal elites on the coasts, and I don't need Republican "moderates," who are backing away so fast they're falling all over themselves.

I don't need any of this as long as I have 90 percent of half the country ready to die for me. Social Media is mine. Television is mine. I am the Great Communicator, not Reagan. I learned this all in the Tabloid Era in New York—junk culture and headlines in the *Post*, as Roy Cohn was my witness. This is what people want, now.

This is a whole new political game, and I'm the only one who saw it coming. All of these politicians are still playing the old game, and as long as they're doing that, I'll grow stronger and stronger. Nothing can stop me now. The numbers are with me.

—June 10, 2018

following pages

— Donald Trump waves farewell to the crowd at
a rally at Verizon Center on the eve of the
New Hampshire primary. Manchester, NH. 2016.
Photo by Peter van Agtmael, Magnum Photos.

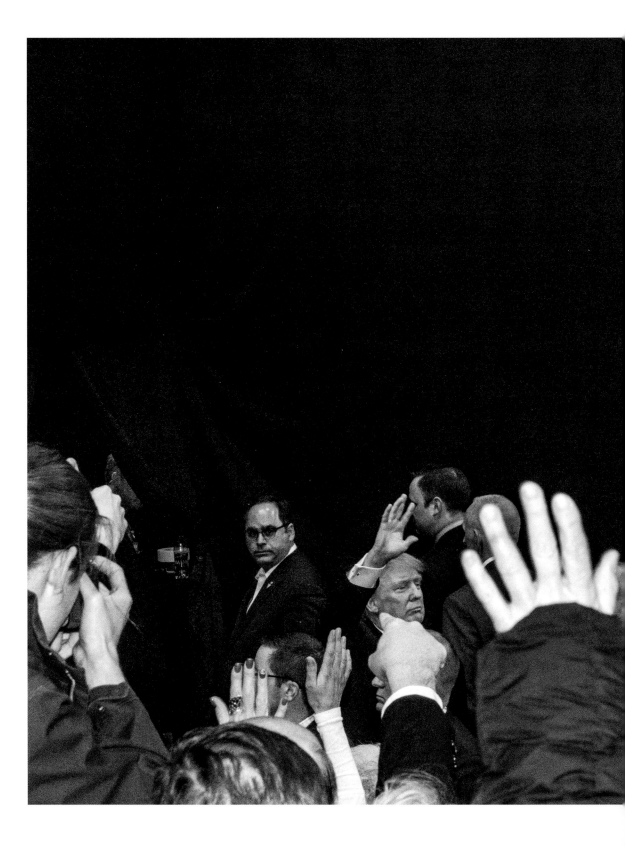

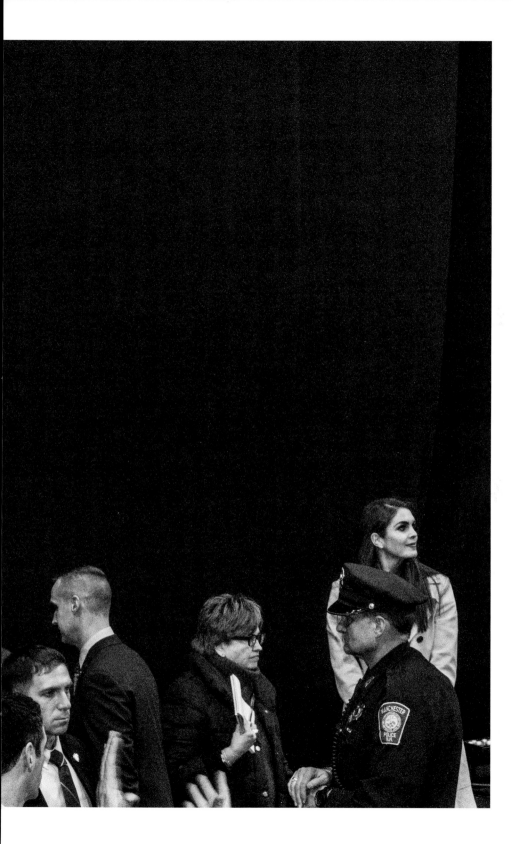

CHAOS THEORY

Chaos can sometimes be a strategy.

Peggy Noonan, Ronald Reagan's speechwriter

Chaos comes before all principles of order & entropy,
it's neither a god nor a maggot, its idiotic desires
encompass & define every possible choreography,
all meaningless aethers & phlogistons: its masks
are crystallizations of its own facelessness,
like clouds.

Hakim Bey, *T.A.Z.: The Temporary Autonomous Zone*

—June 11, 2018

THE FUTURE REMAINS TO BE WRITTEN

He's got a great personality. He's a funny guy, a smart guy, and a great negotiator.[46] I really liked producing that film for Kim, and I think that may be my ultimate destiny, to make great films like that.[47] Maybe I'll hire Steve Bannon back to help, and we'll go into it together. Or, who knows, maybe I'll make one with Kim. For this one, I knew that Kim would like it because it turns out he has a similar aesthetic to mine. If you look at some of the buildings he's made in Pyongyang, they're not too far from Trump style. They're beautiful.

It's a rough situation over there. Rough people, and a rough situation. I'm not saying he's nice. But I'll tell you, he's one of 10,000, in the way he took over at age twenty-six or whatever it was. Very impressive. He has full control of his country. When he speaks, his people hang on every word. I'd like that to happen here.

I said, "Kim, do me a favor. Close the missile engine testing site." And he did! I don't have to verify because I've got like one of the best memories of all time.

I liked him right away. I'm like James Franco in that film Kim didn't like.[48] I felt like taking him under my wing and teaching him a few things about how things work out here in the free world. I don't know how locked in he is to that whole socialist thing. I told him he needs to think more like a businessman. I mean, he's sitting on a goldmine, frankly, in terms of real estate potential alone. North Korea has great beaches and could have great golf courses and hotels. We could make some deals. Putin and I could help him get started.

Nuclear is really number one for me. This is really an honor for me, to save the world. I want to do it.

—June 12, 2018

ZERO TENDER AGE TOLERANCE

Democrats are the problem, and the Fake News is their mouthpiece. They all want illegal immigrants, no matter how bad they may be, to pour into and infest our country. The Democrats see these bad people, rapists and murderers, as their potential voters. That's why they want them to come in.

The courts are also defending them. The so-called "justice" department. We're changing that, but it's taking too much time. Their actions against us are the last gasp, believe me. The Flores settlement, the ACLU suit, the New York State suit, these are all their final efforts.[49]

I mean, look, I don't like the sight or the feeling of children separated from their parents. I have to go on my gut with this. But you have to look at the Bigger Picture. What about all the children permanently separated from their parents because they're killed by MS-13 and other gang members? What about the children who are raped by illegal aliens who have been caught for some other crime and then released? What about them? Who's speaking for them?

Me, that's who. I'm their Voice. I'm the Voice of all people who've been left behind, all those who nobody listens to. And no amount of heart-wrenching pictures of infants crying is going to stop me.

—June 19, 2018

Richard Spencer, American white nationalist known for promoting white supremacist views and coining the term "Alt-right." Spencer advocates for a white homeland for a "dispossessed white race" and calls for "peaceful ethnic cleansing."

Shortly after the election of Donald Trump, Spencer faced criticism when video emerged from the annual conference of his organization, the National Policy Institute. As Spencer proclaimed, "Hail Trump, hail our people, hail victory!" the crowd erupted into cheers and Nazi salutes. He also referred to his critics using the term *Lügenpresse* (lying press), a word popularized by the Nazis.[50] Clarendon, Virginia. 2016. Photo by Peter van Agtmael, Magnum Photos.

THE WHARTON SCHOOL

Have you ever noticed how they always call the other side "The Elite"? "The Elite"! Why are *they* the Elite? I have a much better apartment than they do. I'm smarter than they are. I'm richer than they are. I became President, and they didn't.

They're not the elite. *I'm* the elite.[51] And now everyone knows it. But it eats at them, oh yeah, it eats at them. They know that I know that they're fake. The whole thing is rigged. And so they're going to do whatever they can to destroy me. To destroy *us,* and everything we're building.

I've been dealing with this my whole life, but you should get ready for it. Get ready to fight back with everything you have. Do we believe in the Second Amendment? You bet your *life* we do! If they come to take away your guns, they're going to have a rude awakening, aren't they? The "justice" department? The crooked FBI? The whole Deep State?

And what about when they come to take your President, after the witch hunt? After whatever trumped up charges they devise? What are you going to do to stop them?

Ninety percent of all Republicans are behind me now. So, the battle is going to be between us and them: Republicans versus Democrats, Right versus Wrong. Now don't get me wrong. I'd prefer this to be resolved in an election. But if the election is rigged, and they say I lost, then what? You saw how they reacted when I won the last time!

I don't want to have to suspend the Constitution and declare Martial Law, but what if they force me into it? What am I going to do? Back down? You know me better than that.

—June 20, 2018

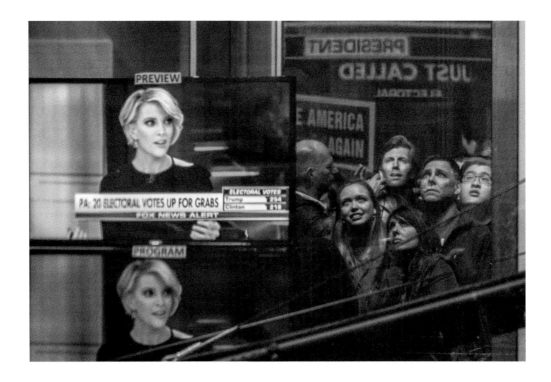

— Early in the morning after Election Day. People watch
the returns coming in at Fox News headquarters
as Trump edges toward victory. Donald J. Trump won
the election in a startling reversal of expectation.
New York City. November 9, 2016. Photo by Peter van
Agtmael, Magnum Photos.

INDEPENDENCE DAY

When I introduced the President of the Netherlands to someone the other day, he corrected me and said it's actually "The Kingdom of the Netherlands." And then he told me that a part of their kingdom is actually in the Caribbean! And there's a King now that used to be The King of Orange! Can you believe it? I had no idea. The Enemies of the People always say that I never learn anything, but I learn more than they do. More than anyone, really.

The other day, I learned a lot from the King of Jordan about the history of the Middle East. Hey, another king! This king thing is growing on me.

So, Happy Fourth of July! You should celebrate especially hard today because of all the changes I've made in the country. I've made it so much better! And it hasn't even been that hard. I mean, yeah, it would be hard for someone else to do it. But for me, it's been, like, a blast. Yes, I get angry when the Fake News tells lies and makes up stories every day, and people who I thought were my friends like Mike Cohen start to weaken and squeal, but overall, we're doing great.

If we can just keep going for a little while longer, we'll get everything lined up and then things will really get better. No more immigrants coming in, no more preferences for Black and brown people.

If we can just get the Supreme Court lined up and hold onto the Congress, really, nothing can stop us. We'll finally be truly Independent. That's going to be a great Independence Day!

—July 4, 2018

MY GUY IN MOSCOW

I just love being around him. I don't know why. I love the way he moves, the things he says, I could just watch him for hours. Whenever he's around, I just feel better, and I can't help but smile. I don't know what else to say.

Do I remember when we first met? No. I know it was a long time ago. The images from then are a little blurry to me now, like out of a dream. Maybe girls were involved, or maybe it was just the two of us. I don't recall.

He's always said everything is going to work out, and I've always believed him. The way he says things, they have to be true. He says I should relax and go with my gut and I do. I feel anxious when he's not around, but I still go on as he's told me to.

I know that he would never do anything to hurt me. Why would he do that? He wants the best for me, and for the whole world. People misunderstand him, always have, and they misunderstand our relationship.

I know what it's like to be misunderstood, to be looked down on. He says those days are almost over, that soon everyone will know who he is, and who we are. They'll be sorry they treated us bad, but it will be too late. Too late for them.[52]

—July 17, 2018

THERE'S NO PLACE LIKE SPACE

Yes, I want to save the world, but I also want to be remembered for expanding the world, and get a little credit for it. That's why I thought of "Space Force." It has a good ring to it, doesn't it? "Space Force," a whole new branch of the military, invented by me. Not bad, huh? I think the Generals like it. Well, not the Air Force, but they'll come around. It opens up a whole new "theater" of war for them (as they say)—a whole new place to work out their machines. And there's no place like space.

Silicon Valley has been wanting to move into space for a while now, and not just Elon. It's like a whole new market out there.

Imagine what we could do there. There's so much room, we could blow up as many nuclear weapons as we want, and it wouldn't have all those negative things attached to it. But we have to get there first, before anyone else, so we can establish dominance. First rule of real estate. That and "do it with somebody else's money."

Maybe I can get Putin to come in with us. I know he loved all the Soviet space stuff, and misses it. *Sputnik*. Gagarin. Space Dogs. He loved it all. It's a good thing, not a bad thing.

And think of the images that will come out of it! The first thing we have to do is design a logo and uniforms.

—August 10, 2018

— A Trump support sign on the lawn of
a neighbor of a KKK member.
Maryland. 2016. Photo by Peter van
Agtmael, Magnum Photos.

MY LOWLIFE DOG

Nondisclosure agreements are just a legal hedge against alliances that go bad. If you're going to stay in the game, you have to make alliances, and they shift all the time. When someone likes me, and says nice things about me, I like them back. But someone might like you now, and when they find out you've screwed them behind their back, they might turn on you. And when they're fired, they will definitely turn on you. So, you have to protect yourself.

As I told Don Junior when he was just a boy, "Don't trust anyone!" Then I'd say, "Do you trust me?" and he'd say, in his tiny little voice, "Yes, Daddy," and I'd say, "No, no, I told you not to trust *anyone*!" Especially me! Jeez, he still hasn't learned that lesson. You know, I wish him the best, but I'm not going to go down with him.

I didn't get to this point by trusting my friends. I mean, I have friends like you have on Facebook: "friends." It's business, you know. As soon as it's in their interest to turn on you, they will. I don't get angry about this—I get even. Watch what happens to Omarosa.[53] She was right when she said, early in our time here, that me becoming the most powerful man in the universe was the ultimate revenge. It's like being a god, like being immortal. No mortal can touch me. Mueller is mortal.

You can't be a "whistleblower" when everything we're doing is right out in the open. I told the American people exactly what I was going to do and they said, yes, that's what we want. They elected me. So, blow your little whistle all you want, girl, nobody's listening.

Roy Cohn would have understood all this. God, I miss him. He should have been a whole Show just by himself. Well, not by himself, I mean with a bunch of lowlife, low-IQ people who he manipulates. Where's my Roy Cohn? Rudy's okay, but he lacks Roy's balls.[54] Roy would kill a close friend of his—cut him or her up with a fillet knife, slowly—and then go out for a nice trout at Elaine's. He was something.

Now I'm surrounded by low-IQ people and lowlifes, and I have to do everything myself. It's tiring. Maybe I should get a dog.

—August 14, 2018

BELIEVE ME

Fake News (all broadcast news except Fox) is against me. The newspapers are all against me (we haven't even tried to take them over, since they're all failing on their own!). Hail Twitter! Hail Facebook! Hail WikiLeaks! (I love WikiLeaks.) Hollywood is mostly against me (Clint, where are you?). Most writers and artists are against me (mostly out of jealousy, let's face it!). There are about fifty books being published every month or so spreading lies about me (including this one!). And they're all in collusion. The collusion against me is huge!

And still we're winning. We're winning everywhere, across the board! How could this be? It's because none of this matters anymore. My People don't pay any attention to any of this, anymore. They pay attention to me. They don't believe you. They believe me.

They're tired of being told that they can't understand what's happening because it's too complicated. I'm telling them something different. I'm telling them what's actually happening. They only have to pay attention to me. It's a big relief to them. I don't judge them. I don't teach them. I lead them. I'm giving them a new image to believe in.

They believe me when I tell them that the game has been rigged against them for a long time. It's been rigged so that they can't win, no matter what they do. They look around and they see it. They just keep losing things. I'm telling them that if they listen to me, they can win again. And they're feeling that. They believe it.

As long as enough of them believe that, you can rail all you want. You can rant and rave and hold your nose and cover your ears. You can threaten me with the law and the "justice" department. You can stomp up and down and say this can't be happening. But it is happening. Believe me.

Welcome to the new New World. Welcome to the New Image.

—August 16, 2018

CODA

An unknown boatman ... has just told me that a
Great Wall is going to be built to protect the Emperor.
For it seems that infidel tribes, among them demons,
often assemble before the imperial palace and
shoot their black arrows at the Emperor.

Franz Kafka, "The News of the Building of the Wall"[55]

Trump's Wall was never a real thing to repel real invaders. It was a symbol, to keep out symbolic invaders that could be repeatedly, symbolically, subdued, while America's actual enemies breached the virtual firewalls and paywalls of our cyber defenses, to corrupt our communications, to bring this destructive regime to power, and to poison the public imagination.

The Trump phenomenon went from candidacy to presidency to 24/7 omnipresence in a very short period of time. The utter dominance of the entire televisual and telematic space was achieved relatively effortlessly, and this sudden takeover of attention served to distract us from the concomitant larger changes in the public imaginary, which will be far more consequential in the long run.

Over the past twenty years, we have built a communications environment in which the loudest, most intransigent, and ignorant voices dominate public speech because they have a structural, tactical advantage. The person or entity that gets the most hits fastest wins. Speed has a politics.

One of the first axioms of the Internet was "Information wants to be free," uttered by Stewart Brand in 1984. But it turned out that our information, even our most trivial information, is worth a fortune when collected and combined. The entire communications revolution was designed primarily to harvest and control this valuable information.[56]

In the fall of 2016, some enterprising political operatives decided to collapse the previous boundaries between popular consumer online language and political language, and Trump became their vehicle. His vehicle became Twitter. Political speech shifted hosts overnight from a president who was a real writer and a superb orator, to a president who used the language of Twitter—based on resentment, recrimination, and revenge—and the techniques of reality TV—deflection,

distraction, and disinformation—based on a whole new area of R&D in communications. It should be remembered that Trump, too, always wanted to be a writer.

People voted for Trump for the same reason they embraced new media technology: because both promised to disrupt the old order. And in both cases, the problem was that no one asked what the disrupters actually stood for and what they wanted. Trump held nominally moderate political views (in the context of the Democratic party in New York City) for most of his life, but when the Reality Effect took hold, the implicit politics of it, which are inherently reactionary, took control. Trump is a transactional tyrant.

Trump's politics became authoritarian, but the politics he used to build and maintain support have been part of the American story from the beginning. What is new about the Trump phenomenon is its unprecedentedly rapid transformation of public language and images. What used to take years or decades to achieve was accomplished in weeks and days.

The conventional view became that new technology has changed everything and therefore previous insights and histories are no longer relevant. The past is no longer prologue; it's just past. Move fast and break things, and let somebody else clean it up.

The rise of Trump has proved once and for all that there is nothing inherently politically progressive about new technology, and that new communications technologies are in fact entirely well-suited to authoritarianism.

These new communications technologies were sold to the public (under Stewart Brand's dictum) as democratizing techniques. In fact, they have been used in the service of the most fundamental threats to democracy. They have been used to limit, degrade, and cheapen public speech, and to make public dialogue and discourse virtually impossible.

The rapid erosion of dialogue and discourse is an existential threat to democracy. If you cannot contend and argue in good faith, then you are left with the imperative to dominate and suppress the views of your opponents. That's all that's left. You're either for me/us, or you're against me/us. There's nothing to discuss. There's no basis for discussion.

With no possibility of agreement about terms or conditions or established facts, the basic ground of reasoned argument has been eroded. We've entered the Dust Bowl of Discourse.

Toxic unreason still has to find targets and enemies, and if these are not apparent, one must invent or inflate them: Immigrants, Socialists, Fake News, the Deep State, Climate Scientists, Science as a whole ("scientists have a political agenda"). These are the agents of your dismay, and the reasons for your increasing distress.

And then someone appears who understands your position and who channels your discontent and resentment. Someone who has been dismissed and demeaned by the Elites his entire life. An anti-Hero for our time. He gets us. He thinks/talks/tweets just like us. He will be our Voice.

The collateral damage in this rebellion has been the language of politics itself. When it is all over, we are going to have to rebuild the infrastructure of civil discourse and of public speech. As with the financial crisis of 2008, it has been sobering to discover just how fragile this infrastructure turns out to be. Perhaps we need to find another way to communicate about important things.

"Collusion" is an old word, used by Chaucer in more or less its current sense, meaning to act together or conspire with others in a fraud. But in its root sense, it literally means "to play with": col- (with) + ludere (to play). The word "illusion" also derives from ludere, and refers to a deceptive appearance or impression or a false idea or belief. It involves the attribution of reality to something that is unreal. It's all about playing around with reality. It's what we do. Homo ludens.

It is common in fraud cases to find that the perpetrator is congenitally unable to tell the truth and doesn't really grasp what "the truth" means. It turns out that just lying outright and in the open can work pretty well for a considerable length of time, especially if one becomes a celebrity and uses the media well.

In a larger frame, the main bet in America has always been between the media and the law. Trump bet on the media his whole life and won, for the most part. His sense of the "law" came primarily from Roy Cohn, and is entirely venal and transactional. Now, sitting in the White House, Trump watches the new Fox News, CNN, MSNBC, and the other channels he more or less created, on mute, scanning the chyrons for fuel, while his "lawyers" play the media.

The outlaw/lawman dyad is one of the most persistent tropes in American mythology, and it has played out here with Trump vs. Mueller as a media spectacle.

In the end, as Kafka knew, the Law is preeminent, but mysterious. "Before the Law stands a doorkeeper," he writes. One day a man comes from the country and asks the doorkeeper for entrance to the Law. The doorkeeper says not today, but maybe it will be possible another day. The man thinks this is unfair, since the Law should be available to everyone at all times. But still he waits, and waits, and waits, for years, at the gate, constantly pleading with the doorkeeper for admittance to the Law and repeatedly being rebuffed. More years pass. Finally, as the man is dying, he asks the doorkeeper something he had never thought to ask before; namely, why no one else, in all these years, has come to this gate to seek access to the Law, to which the doorkeeper replies, "No one else could ever be admitted here, since this gate was made only for you. I am now going to shut it."[57]

NOTES

1 *The Complete Lincoln-Douglas Debates of 1858*, edited by Paul M. Angle (Chicago: University of Chicago Press, 1991), 128.

2 Gregory Krieg, "Amnesty International Sending 'Human Rights Observers' to Conventions," CNN.com, July 14, 2016, https://www.cnn.com/2016/07/14/politics/amnesty-international-human-rights-observers-conventions/index.html.

3 Adapted ("brown acid" to "orange acid") from the announcement made in 1969 by Chip Monck, the lighting designer drafted to be the Master of Ceremonies at Woodstock. A little while later, he made this announcement: "The rain's coming. Try to protect yourselves, try to cover up and let's just ride this out together." Monck was also the lighting designer at Altamont four months after Woodstock, and for the Muhammad Ali/George Foreman fight in Zaire in 1974. See Rick Campbell, "Chip Monck: The Man Who Shined Light on Woodstock," *Houston Chronicle*, August 18, 2009, https://blog.chron.com/40yearsafter/2009/08/chip-monck-the-man-who-shined-light-on-woodstock/.

4 Adapted from lines in Donald Trump's acceptance speech at the RNC; see "Full Text: Donald Trump 2016 RNC Draft Speech Transcript," *Politico*, July 21, 2016, https://www.politico.com/story/2016/07/full-transcript-donald-trump-nomination-acceptance-speech-at-rnc-225974.

5 Michael Moore, "5 Reasons Why Trump Will Win," *Huffington Post*, July 23, 2016, last updated July 24, 2017, https://www.huffpost.com/entry/5-reasons-why-trump-will_b_11156794.

6 Robert Anton Wilson, *Reality Is What You Can Get Away With* (Tempe, AZ: New Falcon, 1992); Timothy Leary, with Robert Anton Wilson and George Koopman, *Neuropolitique* (Tempe, AZ: New Falcon, 1988), 93.

7 David Brooks, "The Democrats Win the Summer," *New York Times*, July 28, 2016, https://www.nytimes.com/2016/07/29/opinion/the-democrats-win-the-summer.html.

8 Jane Mayer, "Donald Trump's Ghostwriter Tells All," *New Yorker*, July 25, 2016.

9 McCain's statement was widely quoted in the media. See, for example, Jennifer Steinhauer, "John McCain Denounces Donald Trump's Comments on Family of Muslim Soldier," *New York Times*, August 1, 2016, https://www.nytimes.com/2016/08/02/us/politics/john-mccain-denounces-donald-trumps-comments-on-family-of-muslim-soldier.html.

10 Trump ally Roger Ailes was fired as chairman and chief executive of Fox News on July 21, 2016, after allegations of sexual harassment. See, for example, John Koblin, Emily Steel, and Jim Rutenberg, "Roger Ailes Leaves Fox News, and Rupert Murdoch Steps In," *New York Times*, July 21, 2016, https://www.nytimes.com/2016/07/22/business/media/roger-ailes-fox-news.html. Ailes went on to advise Trump in his preparation for the presidential debates in August 2016, although the Trump campaign initially denied it; see Maggie Haberman and Ashley Parker, "Roger Ailes Is Advising Donald Trump Ahead of Presidential Debates," *New York Times*, August 16, 2016, https://www.nytimes.com/2016/08/17/us/politics/donald-trump-roger-ailes.html.

11 Michael Hainey, "Clint and Scott Eastwood: No Holds Barred in Their First Interview Together," *Esquire*, August 3, 2016, https://www.esquire.com/entertainment/a46893/double-trouble-clint-and-scott-eastwood/.

12 At the Republican National Convention in Tampa, Florida, in 2012, Clint Eastwood gave a rambling endorsement of Mitt Romney for president that mostly consisted of Eastwood addressing an empty chair that represented President Barack Obama for twelve minutes in prime time. Thirty-three million people saw it live. See Amy Argetsinger and Philip Rucker, "Clint Eastwood Shoots from the Hip at GOP Convention—and Gets Some Blowback," *Washington Post*, August 31, 2012.

13 Michael Moore, "Trump Is Self-Sabotaging His Campaign Because He Never Really Wanted the Job in the First Place," *Alternet*, August 16, 2016, https://www.alternet.org/2016/08/trump-self-sabotage-campaign/.

14 Thomas Hardy, "Dole Urges Hollywood to Stay in Focus," *Chicago Tribune*, July 31, 1996, https://www.chicagotribune.com/news/ct-xpm-1996-07-31-9607310175-story.html.

15 See, for example, Aaron Blake, "Donald Trump Finally Said Something So Bad He Had to Apologize," *Washington Post*, October 8, 2016, https://www.washingtonpost.com/news/the-fix/wp/2016/10/07/donald-trump-finally-said-something-so-bad-he-had-to-apologize-kind-of/?utm_term=.0ce781e776f0.

16 Mark Burnett created and co-produced *The Apprentice* (NBC). Rose Mary Woods was President Richard Nixon's secretary while he was in the White House; she claimed to have accidentally erased some of the eighteen-and-a-half minutes missing from Nixon's tape recordings.

17 Donald Trump's statement can be found in "After Vowing to 'Never' Withdraw, Donald Trump Greets Supporters amid Tape Controversy," *Hollywood Reporter*, October 7, 2016, https://www.hollywoodreporter.com/news/donald-trump-tape-says-he-would-never-withdraw-936554. For Melania's statement, see Elahe Izadi, "Melania Trump Says Billy Bush 'Egged On' Her Husband," *Washington Post*, October 18, 2016, https://www.washingtonpost.com/news/arts-and-entertainment/wp/2016/10/17/melania-trump-says-billy-bush-egged-on-her-husband/?utm_term=.fe40e581b8f0.

18 "Transcript: Donald Trump's Speech Responding to Assault Accusations," NPR, October 13, 2016, https://www.npr.org/2016/10/13/497857068/transcript-donald-trumps-speech-responding-to-assault-accusations.

19 See, for example, Patrick Healy and Jonathan Martin, "Donald Trump Won't Say If He'll Accept Result of Election," *New York Times*, October 19, 2016, https://www.nytimes.com/2016/10/20/us/politics/presidential-debate.html.

20 Adam Curtis, quoted in Jonathan Lethem, "It All Connects: Adam Curtis and the Secret History of Everything," *New York Times Magazine*, October 27, 2016, https://www.nytimes.com/interactive/2016/10/30/magazine/adam-curtis-documentaries.html.

21 Barack Obama on *Real Time with Bill Maher*, HBO, November 4, 2016. Quotations from the broadcast are the author's own transcript.

22 Stewart Brand said this at the first Hackers' Conference in 1984; the statement was later printed in a report and transcript from the conference in the *Whole Earth Review* (May 1985), 49. In Brand's book *The Media Lab: Inventing the Future at MIT* (New York: Viking Penguin, 1987), he begins a section with the words "Information Wants to Be Free" (202).

23 These are Mark Zuckerberg of Facebook, Jeff Bezos of Amazon, Eric Schmidt of Google, and Steve Jobs of Apple.

24 The morning after firing FBI Director James Comey, Donald Trump met with Russia's foreign minister, Sergey Lavrov, and the Russian ambassador to the United States, Sergey Kislyak, at the White House. See, for example, David E. Sanger and Neil MacFarquhar, "With Awkward Timing, Trump Meets Top Russian Official," *New York Times*, May 10, 2017, https://www.nytimes.com/2017/05/10/world/europe/trump-russia-foreign-minister-sergey-lavrov-meeting.html.

25 In an interview before the 2016 election, Steve Bannon described Trump as a "blunt instrument for us," and added, "I don't know whether he really gets it or not." In Ken Stern, "Exclusive: Stephen Bannon, Trump's New C.E.O., Hints at His Master Plan," *Vanity Fair*, August 17, 2016, https://www.vanityfair.com/news/2016/08/breitbart-stephen-bannon-donald-trump-master-plan.

26 For background, see Jonah Engel Bromwich, "'Morning Joe' Hosts: Conway Said She Needed a Shower after Speaking for Trump," *New York Times*, May 15, 2017, https://www.nytimes.com/2017/05/15/business/media/mika-joe-kellyanne-conway.html.

27 See, for example, Jessica Gresko, "Melee outside Turkish Ambassador's Home Left Injuries, Shock," AP News, May 19, 2017, https://apnews.com/43adafb0654245fd9edd6a409732604a.

28 Vladimir Putin, quoted in Ian Phillips and Vladimir Isachenkov, "Putin: Russia Doesn't Hack But 'Patriotic' Individuals Might," AP News, June 1, 2017, https://apnews.com/281464d38ee54c6ca5bf573978e8ee91.

29 Upon being "removed" from his position as White House chief strategist, Steve Bannon said, "I'm leaving the White House and going to war for Trump against his opponents—on Capitol Hill, in the media, and in corporate America." See Ben Jacobs, "Steve Bannon, Chief White House Strategist, Removed from Role," *The Guardian*, August 18, 2017, https://www.theguardian.com/us-news/2017/aug/18/steve-bannon-white-house-trump-administration. Bannon was also quoted by some sources as saying, "Now I'm free. I've got my hands on my weapons." See Vittorio Hernandez, "Ex-chief Strategist Declares Trump Presidency Over," Blasting News, August 20, 2017, https://us.blastingnews.com/news/2017/08/ex-chief-strategist-declares-trump-presidency-over-001944805.html.

30 Julian Assange with Jacob Appelbaum, Andy Müller-Maguhn, and Jérémie Zimmermann, *Cypherpunks: Freedom and the Future of the Internet* (New York: OR Books, 2012), 1.

31 In her speech to the Democratic National Convention on July 25, 2016, first lady Michelle Obama explained how she and Barack taught their daughters to respond to the vitriol the family experienced while in the White House: "our motto is, when they go low, we go high." See "Transcript: Read Michelle Obama's Full Speech from the 2016 DNC," *Washington Post*, July 26, 2016, https://www.washingtonpost.com/news/post-politics/wp/2016/07/26/transcript-read-michelle-obamas-full-speech-from-the-2016-dnc/?utm_term=.2152d910f8e0.

32 During an interview with former Arkansas Governor Mike Huckabee on the Christian station Trinity Broadcasting Network, Trump said, "The media is really, the word, one of the greatest of all [the] terms I've come up with, is 'fake.' I guess other people have used it, perhaps, over the years, but I've never noticed it." See Chris Cillizza, "Donald Trump Just Claimed He Invented 'Fake News,'" CNN.com, updated October 26, 2017, https://www.cnn.com/2017/10/08/politics/trump-huckabee-fake/index.html.

33 After his victory in the Nevada primary in February 2016, Trump exclaimed, "We won the evangelicals. We won with young. We won with old. We won with highly educated. We won with poorly educated. I love the poorly educated." See Josh Hafner, "Donald Trump Loves the 'Poorly Educated'—and They Love Him," *USA Today*, February 24, 2016, https://www.usatoday.com/story/news/politics/onpolitics/2016/02/24/donald-trump-nevada-poorly-educated/80860078/.

34 Roy Cohn (1927–1986) was Senator Joseph McCarthy's chief counsel in the Army-McCarthy hearings and assisted in McCarthy's investigations into suspected communism. Donald Trump met Cohn in 1973, when Trump was twenty-seven, and became his dutiful student of the dark arts. Cohn taught Trump how to bend and break the law to amass power and money. Fellow lawyer and longtime acquaintance Victor A. Kovner said, "You knew when you were in Cohn's presence you were in the presence of pure evil." See Marie Brenner, "How Donald Trump and Roy Cohn's Ruthless Symbiosis Changed America," *Vanity Fair*, June 2017, https://www.vanityfair.com/news/2017/06/donald-trump-roy-cohn-relationship.

35 John Bolton became Donald Trump's national security advisor on April 9, 2018. He is a foreign policy hawk who has advocated regime change in Iran, Syria, Libya, Venezuela, Cuba, Yemen, and North Korea, and was a principal architect of the Iraq War. Bolton considered running for president of the United States in 2012.

36 Joseph Beuys to his students in Beuys, *Dialogue with the Public* (New York: Cooper Union, 1980). Video courtesy Electronic Arts Intermix, New York.

37 Cambridge University psychologist Aleksandr Kogan developed an app to mine Facebook data for Cambridge Analytica, a company founded by Steve Bannon with Robert Mercer, a wealthy Republican donor, to collect political data. See, for example, Kevin Granville, "Facebook and Cambridge Analytica: What You Need to Know as Fallout Widens," *New York Times*, March 19, 2018, https://www.nytimes.com/2018/03/19/technology/facebook-cambridge-analytica-explained.html.

38 On Ivanka Trump's role in Donald Trump's decision to bomb Syria, see Alexander Smith, "Eric Trump Says Syria Strike Was Swayed by 'Heartbroken' Ivanka," NBC News, April 11, 2018, https://www.nbcnews.com/news/world/eric-trump-says-syria-strike-was-swayed-heartbroken-ivanka-n745021. For background on Obama's "red line," see Haley Bissegger, "Timeline: How President Obama Handled Syria," *The Hill*, September 15, 2013, https://thehill.com/policy/international/322283-timeline-of-how-president-obama-handled-syria-.

39 A reference to Trump's personal lawyer Michael Cohen, who made hush money payments to two women with whom Trump allegedly had affairs around the time his youngest son was born. On April 9, 2018, the FBI raided Cohen's office and home, and on April 26, 2018, "Trump acknowledges that Cohen represented him in the 'crazy Stormy Daniels deal.' He tells *Fox & Friends* that 'there were no campaign funds going into this which would have been a problem.'" See "Timeline: From 'Nothing to See Here' to Cohen's Guilty Pleas," AP News, August 22, 2018, https://apnews.com/f2332f042d2849d8b6bd34cb9d9b7a83. Cohen began a three-year prison sentence in May 2019 for campaign finance violations and tax evasion, among other crimes.

40 Quoted in Maureen Dowd, "Trump, Our 'Yosemite Sam' Cartoon Nobel Laureate," WRAL.com, April 29, 2018, https://www.wral.com/our-cartoon-nobel-laureate/17517637/.

41 Rapper Kanye West, a Trump supporter, had tweeted on April 25, 2018, on Twitter.com: "You don't have to agree with trump [sic] but the mob can't make me not love him. We are both dragon energy. He is my brother. I love everyone. I don't agree with everything anyone does. That's what makes us individuals. And we have the right to independent thought."

42 For background on the rumors following the first lady's surgery and month out of public view, see Katie Rogers, "Melania Trump Appears in Public after 'a Little Rough Patch,'" *New York Times*, June 6, 2018, https://www.nytimes.com/2018/06/06/us/politics/melania-trump-rumors-presidential-twitter.html. As was widely reported, Trump misspelled his wife's first name in his tweet after her hospitalization. See, for example, Harriet Sinclair, "Who Is Melanie Trump? President Donald Trump Appears to Forget His Wife's Name," *Newsweek*, May 20, 2018, https://www.newsweek.com/who-melanie-trump-president-appears-forget-his-own-wifes-name-935648.

43 In the spring of 2018, Trump pardoned Scooter Libby (assistant to Vice President Dick Cheney), African American boxer Jack Johnson, and conservative political commentator Dinesh D'Souza, but not lifestyle businessperson Martha Stewart or former Illinois Governor Rod Blagojevich. See Jeremy Diamond, "Trump Floats Martha Stewart Pardon, Rod Blago-jevich Commutation," CNN.com, updated May 31, 2018, https://www.cnn.com/2018/05/31/politics/martha-stewart-rod-blagojevich-trump-pardons/index.html.

44 A reference to a statement by President George W. Bush in 2006; see, for example, "Bush: 'I'm the Decider' on Rumsfeld," CNN.com, April 18, 2006, http://www.cnn.com/2006/POLITICS/04/18/rumsfeld/.

45 Kim Jong-un has served as Supreme Leader of North Korea since 2011. He had his uncle executed in 2013 and is believed to have ordered the assassination of his half-brother in a Kuala Lumpur airport in 2017. (See, for example, Julian Ryall, "Did Kim Jong-un Kill His Uncle and Brother over 'Coup Plot Involving China'?," *Telegraph*, August 24, 2017, https://www.telegraph.co.uk/news/2017/08/24/did-kim-jong-un-kill-uncle-brother-coup-plot-involving-china/.) Trump and Kim met in Singapore for the first time in June 2018, following the G7 summit in Quebec, at which Trump refused to sign the G7's closing document.

46 Trump praised Kim Jong-un with these words in an interview with Greta Van Susteren, "Trump to VOA: 'We're Going to Denuke North Korea,'" Voice of America News, June 12, 2018, https://www.voanews.com/a/trump-to-voa-we-re-going-to-denuke-north-korea-/4435044.html.

47 To view the four-minute "Hollywood-style" video that Trump showed Kim Jong-un at their June 2018 summit, see Emily Stewart, "Watch the 'Movie Trailer' Trump Showed Kim Jong-un about North Korea's Possible Future," Vox, June 12, 2018, https://www.vox.com/world/2018/6/12/17452876/trump-kim-jong-un-meeting-north-korea-video.

48 A reference to the film *The Interview* (2014), with James Franco and Seth Rogen. On Kim's reaction to the movie, see Choe Sang-Hun, "North Korea Warns U.S. over Film Mocking Its Leader," *New York Times*, June 25, 2014, https://www.nytimes.com/2014/06/26/world/asia/north-korea-warns-us-over-film-parody.html. Choe writes: "The North Koreans have reacted with their usual bluster, calling the movie an 'act of war' and flinging threats at the Obama administration, which it implied had masterminded the film to undermine their nation."

49 Under then-U.S. Attorney General Jeff Sessions' "Zero-Tolerance" policy, people suspected of crossing the border illegally were held as criminals, and parents and children were immediately separated and sent to different facilities. According to the Flores settlement agreement of 1993, children can be held in federal detention for only twenty days. Public outrage over images of children being taken from their parents and of children sleeping in cages ultimately led the administration to backtrack on its policy of family separation.

50 Daniel Lombroso and Yoni Appelbaum, "'Hail Trump!' White Nationalists Salute the President-Elect," *The Atlantic*, November 21, 2016, https://www.theatlantic.com/politics/archive/2016/11/richard-spencer-speech-npi/508379/.

51 See, for example, Bess Levin, "Trump Wants His Supporters Called the 'Super-Elite' Because 'We Got More Money' and 'Nicer Boats,'" *Vanity Fair*, June 28, 2018, https://www.vanityfair.com/news/2018/06/trump-wants-his-supporters-called-the-super-elite.

52 Donald Trump and Russian President Vladimir Putin met privately in Helsinki on July 17, 2018, before holding a joint press conference.

53 After Omarosa Manigault Newman, a former contestant on *The Apprentice*, was fired from her job as a White House aide, Trump referred to her as "that dog" and a "crazed, crying lowlife" in a tweet (Twitter.com, August 14, 2018). Manigault Newman's harshly critical book, *Unhinged: An Insider's Account of the Trump White House*, went on sale on August 14, 2018.

54 Rudy is former New York City mayor Rudy Giuliani, who began working as one of Trump's personal attorneys in April 2018.

55 Franz Kafka, "The News of the Building of the Wall: A Fragment," translated by Tania and James Stern, in *The Complete Stories* (New York: Schocken Books, 1946), 249.

56 See Yasha Levine, *Surveillance Valley: The Secret Military History of the Internet* (New York: PublicAffairs/Perseus Books, 2018).

57 Franz Kafka, "Before the Law," translated by Willa and Edwin Muir, in *The Complete Stories* (New York: Schocken Books, 1946), 3–4.

ACKNOWLEDGMENTS

The first thirty-five dispatches were posted online in real time on Power2016.net, accompanied by photographs taken by Jon Winet, Allen Spore, and a few by David Levi Strauss.

A version of Dispatch 3, "Alpha Male in the Mist," was published on July 20, 2016, and Dispatches 4 and 5, "A Cold Fear" and "Trump City," were published on July 21 and July 22, 2016, respectively, in *The Public* in Buffalo, New York.

A version of Dispatch 4, under the title "The 'Cold Fear' of Trump's Rise to the Top," and Dispatch 8, under the title "What Would a Trump White House and Silicon Valley Alliance Mean for First Amendment Rights?," were published in *Little Village* magazine, in Iowa City, Iowa, on July 21 and July 22, 2016, respectively.

Dispatches 15–31 were published under the title "Dispatches from the Campaign" in *The Brooklyn Rail* online, October and November 2016.

Sixteen of the dispatches from the conventions were posted on the *Huffington Post* from August 24 to November 23, 2016.

"Prologue in the Theater (After Faust)," "The World on the Screens," and "A Blunt Instrument for Us" appeared in the catalogue for the Biennale für aktuelle Fotografie that occurred in September and November 2017 in Mannheim, Ludwigshafen, and Heidelberg. The catalogue, titled *Farewell Photography*, was published in separate English and German editions by Walther König (Cologne: Verlag der Buchhandlung Walther König, 2017), pp. 141–143. Thanks to Boaz Levin.

INDEX

Page numbers in italics indicate photographs.

Eliot, T. S., 108
elites, resentment of, 42, 73–74, 75, 98, 117, 138
entertainment industry, 63
environment, threats to, 83
Erdogan, Recep Tayyip, 104, 113
Evola, Julius, 108

Facebook, 19, 100, 119, 144, 145, 152n23
"fake news," 97, 104, 115, 140, 148, 153n32
 Democrats associated with, 136
 elites and, 111
 rule of law and, 117, 121, 128
 Trump's definition of, 145
Federal Bureau of Investigation (FBI), 19, 72, 98, 115, 124, 138
 Comey fired by Trump, 95, 153n24
 Mueller's investigation, 117, 144, 149
Federalist Society, 117
Ferrera, America, 30
financial crisis (2008), 148
Flores settlement (1993), 136, 155n49
Flynn, Michael, 13
Foreman, George, 62, 151n3
Fox News, 37, 79, 139, 145, 148, 151n10
Franco, James, 133, 155n48
Frum, David, 79

Gawker Media, 19
generals, military, 38, 59–60, 113–114, 115, 118, 120, 142
Gide, André, 108
Giuliani, Rudy, 4, 69, 124, 144, 156n54
Goldwater, Barry, 17, 22
Gore, Al, 93
Green Party, 38, 48
Guénon, René, 108
guns
 Clint Eastwood image of vigilantism and, 53
 Ohio open carry law, 1, 4
 Second Amendment, 138
 as tools, 119

hackers and hacking, 105
Hainey, Michael, 52
Hill, Jarrett, 7
Hodges, Ames, 45
Hollywood, 145
Holt, Lester, 60
Homeland Security, Department of, 1, 19
House of Representatives, 49
Huckabee, Mike, 153n32
Hulbert, Carmen, 29
Hurricane Matthew, 64
HyperNormalization (Curtis), 77

iconopolitics, xi
Illich, Ivan, 119
image
 image management, 101
 as information, 87
 rapid transformation of public images, 147
 revolution of the, 88
immigrants, 29, 72, 140
 fear of illegal immigrants, 1, 5, 17, 36, 73
 Melania as good immigrant, 7
 as targets, 83, 148
information, 79
 commodification of, 146
 democratization of, 39
 image as, 87
 "information wants to be free," 87, 89, 119, 146, 152n22
 relativity and equivalence of, 77–78
innovation, disruptive, 66–67
Internet culture, 77, 105, 108, 146
Interview, The (film, 2014), 133, 155n48
ISIS (Islamic State in Iraq and Syria), 1, 69, 70, 98
Islam, Radical, 98, 108
Ivins, Molly, 17

Jefferson, Thomas, 48
Jobs, Steve, 89, 105, 152n23
Johnson, Gary, 48, 49
Johnson, Jack, 127, 155n43
Jones, Van, 70
Judeo-Christian civilization, 98, 108

nondisclosure agreements, 144
Noonan, Peggy, 132
Note on the Abolition of All Political Parties (Weil, 1943), 45
Novalis (Friedrich von Hardenberg), 108

Obama, Barack, xiii, 5, 60, 152n12
 Democratic Convention speech (2004), 27
 Democratic Convention speech (2016), 35–36
 as first Black president, 42, 92, 93
 "hope and change" message, 56
 on information and democracy, 79
 perceived as elitist, 93
 Syrian war and, 120
 US military and, 59–60, 113
Obama, Michelle, 7, 28, 30, 44, 153n31
Obamacare, 5
Oklahoma City bombing (1995), 71
organized crime, 121
Other, the, 88
outlaw/lawman dyad, 149

Palantir Technologies, 19
Palin, Sarah, 66
Pandora's Box (Curtis), 77
pardons, presidential, 127, 155n43
Pence, Mike, 1, 16, 48, 69
 Republican Convention speech, 13, *14–15*
 in vice presidential debate, 65
Perot, Ross, 49
Planned Parenthood, 30
Plato, 37
political correctness, 52, 73–74, 92
political parties, collective passion and, 45
polls, 23, 42
populism, 124
Power of Nightmares, The (Curtis), 77
primaries, 13, 46, 47, 57, *112*, 153n33
 polling station in New Hampshire, *116*
 Trump campaigning before New Hampshire primary (2016), *122–123*, 129, *130–131*
privacy, death of, 89, 100
Purchin, Andrew, 2

Putin, Vladimir, 39, 70, 104, 113, 133
 Helsinki meeting with Trump (July 2018), 155n52
 inside the mind of, 105
 "Space Force" and, 142
 Trump's affinity for, 115, 128, 141

Qaeda, al- ("the Base"), 71, 98

racism, xi, 42, 46, 52, 63, 92
Raddatz, Martha, 69
radio, right-wing, 46, 75
Raine, Kathleen, 108
Reagan, Ronald, 17, 22, 52–53, 129, 132
Real, the, 66
"reality tunnel," 37, 38
reality TV, 46, 75, 126, 128, 146
Real Time (TV program), 79
Republican National Convention (Cleveland, July 2016), xi, *8–9*, 22, *76*
 Code Pink protests at, 21
 final celebration at, *61*
 opening night speeches, 5–6
 Pence's speech, 13, *14–15*
 "protest zone" outside of, 11
 public square outside, *96*
 Quicken Loans Arena ("the Q"), 1, 5, 10, 11, 20, 21
 security for, 1, 11–12, 46
 singing of National Anthem at, *x*
 street scene outside, *68*
 Trump family box at, *87*
 Trump's acceptance speech, *3*, 17–18
 welcome events and schedule, 4
Republican National Convention (New York, 2004), xiii, 12, 46
Republican National Convention (Tampa, 2012), 152n12
Republican Party, 16, 18, 46
 approval ratings for Trump among Republicans, 129, 138
 moderate Republicans, 48, 129
 Trump as Republican, 75
 Trump's opinions of, 115

Obama's roast of, 35
opinion polls and, 23, 42, 55, 60, 129
opportunism of, 75, 147
in presidential debates with Clinton, 62,
 69–70, 75
reaction to Democratic National Convention,
 37
reality TV shows of, 57
as Republican nominee, xiii
sexual assault accusations against, 72
Silicon Valley and, 19
speech at Republican Convention, *3*, 17–18
third-party critique of, 48
US military and, 113–114, 118, 120, 142
Trump, Donald, Jr., 10, 17–18, 144
Trump, Eric, 13, 16, 17
Trump, Ivanka, 1, 10, 17–18
Trump, Melania, 1, 4, 17, 97
 on the *Access Hollywood* video, 66
 Donald Trump's feelings about, 118, 120,
 125
 hospitalization of, 125, 154n42
 Republican Convention speech, 5, 7, 13, 28
Trump, Tiffany, 10
Trumpism, xi
Trump supporters/fans, 11, 60
 Access Hollywood video and, 66
 inside the minds of, 92, 93–94, 109–110
 motivations of, 147
 sign on lawn, 143
 Trump's "base," 98
Turkey, 1
Twitter, 46, 146
Tyson, Mike, 104

Ukraine, 39
*Unhinged: An Insider's Account of the Trump
 White House* (Manigault Newman,
 2018), 156n53

van Agtmael, Peter, xiii
VanHoose, Marlana, *x*
Ventura, Jesse, 23
Vietnam war, 81

Waco, siege of Branch Davidian compound
 near (1993), 71
Warhol, Andy, 126
Warren, Elizabeth, 27
Watergate scandal, 81
Weil, Simone, 45
Weld, William, 48, 49
West, Kanye, 124, 154n41
Westboro Baptist Church, 2
"Where Are We Now? Responses to the
 Referendum" (Clark, 2016), 45
whistleblowers, 144
white nationalism, 137
whites, 42, 43, 53
WikiLeaks, 27–28, 39, 71, 145
Wilson, Robert Anton, 37
Winet, Jon, xiii
women
 acceptance of woman as president, 76
 degradation and abuse of, 65, 152n16
 Women's March on Washington (January 21
 2017), 101, *102–103*

xenophobia, xi, 17, 46, 63, 71

Yanukovych, Viktor, 39

Zuckerberg, Mark, 19, 89, 152n23